Seventeenth Century Science
and the Arts

THE WILLIAM J. COOPER FOUNDATION
LECTURES, SWARTHMORE COLLEGE
1960

Seventeenth Century
Science and
the Arts

BY

STEPHEN TOULMIN

DOUGLAS BUSH

JAMES S. ACKERMAN

AND

CLAUDE V. PALISCA

EDITED BY

HEDLEY HOWELL RHYS

PRINCETON UNIVERSITY PRESS

PRINCETON, NEW JERSEY

1961

Publication of this book has been aided
by the Ford Foundation program to support
publication, through university presses,
of works in the humanities and social sciences.

Printed in the United States of America
by Princeton University Press, Princeton, New Jersey

Preface

A N INTEREST in the past and present condition of phi-
losophy, literature, art, or music, either individually
or all together, means some degree of concern with the
history of human intellectual behavior. The intellectual
historian, according to A. O. Lovejoy, deals with "the proc-
esses by which individual and group interests, opinions,
and tastes are formed and the sequences and laws, if any,
of their changes—so far as a knowledge of the acts,
thoughts, and feelings of men in the past may throw light
upon these matters."[1] Such a problem, the interaction be-
tween science and the arts in the seventeenth century, is
the subject of these four essays. They were presented as
lectures at Swarthmore College in the spring of 1960 and
were sponsored by the William J. Cooper Foundation.

In planning a serial discussion of the arts, the Cooper
Foundation committee decided for many reasons to focus
it on the seventeenth century. It is the century which is
being thought of more and more frequently as the begin-
ning of the modern era. Its philosophers and poets are
still read and talked about, its plays are still seen in the
theatres, its music is being rediscovered and when heard
speaks immediately to the sensibility of present-day com-
posers. The dynamic character of its architecture and city
planning has significance for modern building, and a fuller
understanding of its painting and sculpture is perhaps be-
ing hindered only by connotations lingering in the word
"Baroque."

[1] "Present Standpoints and Past History," *The Journal of Philosophy*,
XXXVI (1939), 477-89.

Preface

These were reasons enough. But no one thinking about the seventeenth century can forget that it witnessed the first steps of modern scientific thought. Had they not been taken, our predominantly scientific culture would be inconceivable. The simultaneous occurrence at the beginning of the modern era of a vigorous art and a seminal science invites questions that cannot be avoided or resisted. Was there a connection between these two modes of thought? Was there a continuity of feeling between them? If so, how did they affect each other? Which, if either, was dominant? Asking these questions now, at a time when art and science seem to be poles apart, may be pertinent. But doing so does not necessarily imply participation in the enthusiasm for Mr. C. P. Snow's concept of the "two cultures," or a fulfillment of John Dewey's theory that our selection of significant events in history is based upon the problems we ourselves face. What asking these questions does demonstrate is a deep-seated belief that an objective knowledge of ourselves and our cultural heritage is both possible and desirable.

Four distinguished scholars have contributed their impressive knowledge and skills to the examination and clarification of these questions. It is not necessary to summarize their answers; they speak eloquently for themselves. In presenting their essays to the public, the Cooper Foundation and Swarthmore College express their grateful appreciation to the authors for their creative insights and their valuable contributions to our knowledge and understanding of seventeenth century science and the arts.

HEDLEY HOWELL RHYS

Swarthmore College
March 1961

Contents

Seventeenth Century Science
and the Arts

Seventeenth Century Science and the Arts

STEPHEN TOULMIN

H OW DID the scientific revolution of the seventeenth cen-
tury affect other spheres of human thought and cre-
ation, particularly literature, music, and the arts? Though it
is simply enough stated, the question is a vast and complex
one, not easily answered. I hope I shall be doing my suc-
cessors, as well as you, a service if I make this first essay
something in the way of a preliminary reconnaissance. My
purpose will be to break down our first, large question
into a number of smaller and more manageable ones. For
the thought and art of seventeenth century Christendom,
like the ideas of any age, form a highly intricate web;
and their different strands react on one another in ways
more varied and entangled than the bare statement of our
question suggests.

I shall come at the question from four different direc-
tions. For if we are to get a foothold in our subject, to see
how it can be most profitably attacked, four preliminary
questions call for serious attention. In this way I hope to
pose a little more precisely the problems which my succes-
sors will be unravelling.

These preliminary ground-clearing issues are the follow-
ing:

STEPHEN TOULMIN is Director of the Unit for the History of Ideas,
the Nuffield Foundation, London, England. His works include *Reason in
Ethics*, *The Philosophy of Science*, *The Uses of Argument*, and *The
Fabric of the Heavens*.

3

Stephen Toulmin

I. What was the scientific revolution?

II. Which of the creative arts were immediately affected by it?

III. Was the direction of influence one-way—science affecting other things without being affected in turn?

IV. How did this interaction take place? By what channels of intellectual influence was it exercised?

I. When we speak about the seventeenth century as the period of the scientific revolution, what do we mean? The phrase has been current for just long enough to become confusing, for it implies, rather than explicitly stating, that during the century a widespread transformation took place in men's ideas about nature, which affected all the sciences; as though seventeenth century science had been a unit, which was transformed in all its aspects, as it were, overnight. This picture is much too simple. If there was a revolution in science during the seventeenth century, this was something which affected first and foremost two sciences, both of them physical ones: astronomy and dynamics. Other sciences, chemistry as much as biology, remained unaffected. True, seventeenth century scientists were quick to promise radical changes in those other sciences also, but their promises remained effectively unredeemed for a century or more.

We are chiefly concerned, then, with a revolution in cosmology: that is to say, in men's ideas about the ordered relations between the earth, the stars, and the other celestial bodies. At the beginning of the century, all but a few men in Europe still accepted, at least in its main outlines, the jigsaw picture of the earth and heavens that had been

4

built up during the middle ages from the forcible union
of parts of Greek science with Christian dogma. The im-
mortal heavens were still circling eternally around a cor-
rupt and degenerating earth. The "fixed stars" were still
pattens of pure gold, thick inlaid on the sphere of perfec-
tion which contained and delimited all. The region beyond
this sphere was still identified with heaven. Few people,
perhaps, went so far as to retain in full the old Stoic belief
that the human soul was an ethereal compound of fire and
air, which at death escaped from its earthly prison and pro-
ceeded upwards through the planetary spheres to be re-
united in its own personal star with the divine matter of
the empyrean. That had come to seem rather a gross,
materialistic view of things. Nevertheless, the outermost
heavens were still spoken of as the *Habitaculum Dei et
Omnium Electorum*, the Mansions in the Almighty's
House in which the saints might hope to lodge.

One by one, the seventeenth century saw the chief fea-
tures of this picture destroyed, in gross and in detail. Even
before the turn of the century, Tycho Brahe had drawn
attention to positive evidence that the heavens were not
unchangeable. Just as he was at the peak of his astronom-
ical career, in the 1570's, good fortune presented him with
two successive discoveries: a return of Halley's Comet (the
comet previously depicted in the Bayeux tapestry), which
he was able to prove was moving along a track far out-
side the orbit of the moon; and the appearance of a super-
nova, a new star in the constellation of Cassiopeia, of a
size and brilliance that can be observed, on an average,
only once every 300 years. Thomas Digges, too, had intro-
duced the idea that the starry heavens formed not a single

5

Stephen Toulmin

spherical shell, but an infinite expanse of stars, some of which we can see, while others extend without limit beyond the powers of our vision.

These ideas were powerfully reinforced by Galileo in the early years of the seventeenth century, as a result of his work with the telescope. Galileo also provided many fresh arguments in favor of Copernicus' view that a true perspective of the planetary system can be had only by thinking of the sun as of the center, rather than the earth. In the fifty-seven years following the publication of Copernicus' treatise *On the Revolutions of the Celestial Orbs*, it had won few supporters. Only the fresh arguments brought by Galileo, Kepler, and finally Newton carried complete conviction. Even Descartes hedged on this issue, as he so often did on issues which might lead to conflict with the religious authorities; but after 1687 the success of Newton's theory of gravitation put the merits of the Copernican perspective beyond doubt. The heavens (as Haydn was to proclaim) were still capable of

"telling the glory of God:
The Firmament itself shows forth his handiwork."

But the planetary system, with its miraculous law-governed regularity, had now to be interpreted as a piece of celestial clockwork. The only question was whether the Divine Architect of the Heavens had done his work well, as Newton argued, or whether, as Leibniz retorted, Newtonian mechanics was an insult to God, with the apparent implication that He had to step in from time to time and regulate his planetary machine. At any rate, the angels no

6

longer had to drive the planets around the sky, and the claims of astrology could at last be seriously questioned, while the *Habitaculum Electorum*, the Mansions of the Elect, finally lost its place in the astronomical map of the heavens.

This revolution in cosmology was not a complete surprise: it had been long in preparation. In different ways, Nicolas Oresme in the fourteenth century and Nicolas of Cusa in the fifteenth had been aware of the weakness of the arguments for the geocentric view. For Oresme, neither observation nor reason could provide arguments capable of proving whether the earth was in motion or at rest: this became, therefore, a matter not for argument but for revelation. Cusa went further, arguing that the very question, where the center or outside of the universe was located, inevitably led one into paradoxes, so that it was in vain to suppose that we could answer it. Even Osiander, the editor of Copernicus' book, tried to play down its implications: "I have no doubt that some learned men have taken serious offense because the book declares that the Earth moves, and that the Sun is at rest in the center of the Universe; these men undoubtedly believe that the liberal arts, established long ago upon a correct basis, should not be thrown into confusion." Copernicus, he went on to say, was doing nothing of the sort: his "hypotheses" were not presented as "true nor even probable; if they provide a calculus consistent with the observations, that alone is sufficient." And Milton's Archangel echoed this limited view of astronomy (which had been Ptolemy's) as a convenient compendium of geometrical devices with which to compute tables for the Nautical Almanac:

7

Stephen Toulmin

"how build, unbuild, contrive
to save appearances."

But the message of Copernicus was not to be emasculated in this way. He was very much concerned with the search for the true explanation of the heavenly motions, about which men had speculated ever since the time of classical Greece. One might succeed in insulating the religious picture of the heavens from the effects of observational astronomy alone, but it was impossible to deaden the impact of Newton's planetary dynamics. This at last had the effect of driving the spirits out of the sky.

It did not, however, drive the spirits out of chemistry or physiology. It was all very well Newton's proclaiming the truth of atomism, or "corpuscularianism," as the men of the seventeenth century called it. Practical chemistry remained unaffected. Robert Boyle did his best to apply the corpuscular idea of matter as consisting of solid, massy, hard, impenetrable particles, and succeeded in explaining some of the elementary physical properties of gases: for instance, its elasticity—"the spring of air," in his phrase. But the atomistic idea really took hold in chemistry only in the nineteenth century, with the work of John Dalton of Manchester. In the meantime, seventeenth century chemistry remained part classificatory, part technological: its ideas retained a strong flavor of alchemy, with its "principles" and its transmutations, its planetary symbolism and spiritual overtones. In the middle of the seventeenth century, J. B. van Helmont was still sufficiently influenced by the Stoics to think of different bodies or materials as having formative souls that could be released from their

8

material bondage by heating, and so left free to escape in gaseous form. For him, indeed, a gas (to use the word he himself invented) was a spiritual, living ferment rather than an inert, inanimate stuff.

On this front, the future might lie with men like Newton and Boyle, but in 1700 their success lay still in the future. Even Mayow, who is sometimes applauded as anticipating the discovery of oxygen, spoke of the human body breathing in "nitro-aerial spirits" from the ambient air, and these spirits had a wonderfully protean set of other properties and characteristics. They might have come some way from the Stoic world-soul, which formed the origin of Galen's own "vital spirits," but they had a long way to go before turning into Lavoisier's plain, inorganic "oxygen."

As for physiology itself, this was left unaffected by the seventeenth century revolution. William Harvey, it is true, succeeded in clarifying greatly the nature of the arterial system, and put the course of the circulation of the blood beyond doubt. But this was an anatomical insight, and the working of the body remained mysterious. For Harvey, as for Aristotle and Galen, the lungs were there to cool the blood, and to introduce into it "spirits" from the air, which the blood then carried around to the rest of the body. The animal and vital spirits of Galen's physiology were in fact retained not only by Harvey, but also by Descartes. Although Descartes had announced grandly that animals were simply machines, he did little to enlighten the men of the seventeenth century about the manner in which these machines operated; in this respect, Galen remained more informative than Descartes.

9

In botany, zoology, and geology, the men of the seventeenth century were on the threshold of great discoveries. As the age of exploration progressed, tales of new wonders were beginning to spread. The old boundaries of the subjects would soon be pushed back, as the more distant continents were studied and their fauna and flora compared. A century and more in the future, in the remote islands of the Galapagos group and the Malayan archipelago, Darwin and Wallace would glimpse the operation of natural selection. But of all this, 1700 was only the threshold. For the time being, the old picture of the sovereign order of nature, the hierarchy of living things set in authority over one another by the Almighty, still held men's vision with unweakened power. The Royal Society and the other great national academies of science entered the eighteenth century with large hopes, and the subsequent 250 years have seen these largely fulfilled. For the moment, however, little had been achieved outside the fields of mathematics—especially dynamics—and astronomy. The spatial boundaries of the universe had been smashed. But as for the antiquity of the world and the complex genealogy relating all living things, these were still unguessed.

II. With this nut-shell history of seventeenth century science in mind, we must now turn to our second question. Were all the creative arts equally affected by these changes in science? Or should we expect to find "New Philosophy" (as men called the science of Galileo and the rest) influencing some arts more completely and more directly than others?

As we shall see, seventeenth century literature lent it-

self readily to expressing the ideas of the new philosophy: not surprisingly, for, like Molière's M. Jourdain, the scientists were all bound to write prose. Other arts, notably music and architecture, did not so easily serve as vehicles for the new thought. Vocal music was one thing: Henry Purcell's choral ode "Soul of the World" celebrated discordantly "the jarring, jarring atoms," but elsewhere one does not seriously expect to see cosmological and corpuscularian ideas having any direct impact on musical expression. And in the case of architecture, the influence of these ideas must be even more indirect. This point I will return to later.

III. Thirdly, since we are concerned with an *interaction* between science and the rest of thought and art, the question arises: In what direction did this interaction take place? Is the direction implied in our question correct? Is it really the case that seventeenth century science developed autonomously, of itself, and then in turn acted as an influence on men's other ideas and activities? Was science the prime mover, the locomotive, which pulled the other arts along behind it? Or was it a boxcar that moved and changed because it too was being pulled, by philosophy, say, or religion?

It is true enough to say that science was at any rate not pulled by poetry or the visual arts. However different the poetry and drama, the music and architecture of the seventeenth century had been, the cosmological revolution would have happened, in all its essentials, exactly as it did; whereas, to mention one example only, if Kepler and Galileo had both died in infancy, Milton's *Paradise Lost*

would have been a very different poem. But when it comes to asking whether philosophy influenced science or science philosophy, I must say I feel a great deal less confident. Professor Karl Popper has claimed that philosophical problems, particularly problems in the theory of knowledge, need to be understood as arising out of the problems of contemporary science: this implies that we should think of John Locke, for instance, as the philosophical spokesman for Sir Isaac Newton, rather than of Newton as the scientific disciple of Locke—of the philosophical cart as being pulled by the scientific horse, rather than vice versa. About this I do really have my doubts. In this case, at least, the direction of influence was certainly in part reversed. The scientists of the seventeenth century—if one can without anachronism apply the name of scientist to a man like Newton—owed as much to the philosophers as the philosophers did to the scientists; and in the systems of Descartes and Locke one finds basic ideas thrown out which were not fully developed and exploited until the nineteenth century, with the work of chemists and physicists and physiologists such as Dalton and Helmholtz and Claude Bernard. So the picture of the scientific revolution as being a source of influence on other aspects of thought and art without itself being influenced by other things is only in part an accurate and lifelike one.

IV. For the moment, I want to concentrate on the fourth and most fundamental of these introductory questions: What sorts of cultural interactions can one really believe in? What connections and analogies are intelligible, credible, even possible? The hunt for cultural interactions is

12

both fascinating and hazardous, a task in which the proper course between enthusiasm and scepticism is peculiarly hard to steer. The Enthusiast looks at all the arts and sciences of a period confident that he will find resemblances and parallels between them, and there is no end to the parallels and resemblances which in due course he does find. Late seventeenth century Europe he calls the Age of the Baroque, and in his eyes the physics, music, architecture, and political organization of the period are all aspects of a single phenomenon: they are all baroque. It stands to reason for him that the music of Henry Purcell, the architecture of Christopher Wren, the dynamics of Isaac Newton, and the political arrangements of William of Orange (to speak only of England) must display essential similarities that will mark them clearly off from the works of William Shakespeare, Benjamin Britten, Clerk Maxwell, and that demented King George III. The great span of dome in St. Paul's Cathedral in London mirrors the empty space between the sun and planets in Newton's solar system. They are both in turn reflected in the diplomatic organization of seventeenth century Europe, with its individual nation-states insisting on their absolute sovereignties, and again in the monads of Leibniz's metaphysics . . . to say nothing of the music and painting of the period. All these parallels, mirror-images, reciprocal symbolizations, resemblances, and harmonies are, for the Enthusiast, the many, varied expressions of the *Zeitgeist* or spirit of the times.

For the Sceptic, all this is so much wasted breath. In his eyes, these alleged resemblances are not discovered *in* the facts of history, but are read *into* or imposed *on* them.

13

Christopher Wren was simply adapting to St. Paul's devices already used by Michelangelo in designing St. Peter's; Newton was developing and uniting physical ideas to be found in part in Galileo, Kepler, and Descartes; William III was striking a compromise between Oliver Cromwell and James II: "Politics is neither an Art nor a Science, but a Dodge." The Sceptic sees each of the arts and sciences as developing in its own way, free of all outside influences, and in its turn as uninfluential: art for art's sake, music for music's, paleo-micro-biochemistry for the sake of paleo-micro-biochemistry alone.

Neither of these extreme positions is really good enough: we must find some course to steer between them. The resemblances between the art and music, physics and politics of the 1680's were neither as complete nor as many as the Enthusiast would have us believe; and to put them down to "the spirit of the times" is little enough of an explanation. Yet to brush aside, equally and en bloc, what resemblances there are is at once too sweeping and far too negative. One cannot just deny *all* interaction between science and the arts.

True, there is in some cases a point to the Sceptic's claim. When one writes the recent history of the natural sciences, for instance, it is a fruitful enough maxim to begin always by treating this as an autonomous development; to look at the problems of the physiologist as physiological problems alone, and to account for the changes we find in the concepts of the science in terms of the specific problems with which physiologists were confronted at the time in question. Only when we find changes we cannot account for in this way should we start appealing to outside influ-

ences, whether from other natural sciences or from wider changes in philosophical or religious thought. Still, the maxim can obviously be pressed too far. It is a wise one in the case of sciences that have a certain maturity and theoretical sophistication, such as atomic physics and bio-chemistry, but the more narrowly we draw the bound-aries between our sciences, the less reliable they are: even biochemistry cannot be thought of for long apart from the rest of chemistry and physics and physiology. And one has only to go back a century or more in time from the present day, or move to spheres of thought less monastic in character than the theoretical sciences, for the bound-aries to become more and more indistinct. When we reach the seventeenth century the doors are wide open, and the maxim is no more than a useful caution. Science is natural philosophy—a study beginning, but only beginning, to stand on its own feet. And the professional scientist is a figure two hundred years in the future: all educated men can still join in the scientific debate—Dryden, Fontenelle, John Locke, and even Samuel Pepys rubbing shoulders with Newton, Boyle, and Mariotte.

The Enthusiast one cannot dismiss so quickly. His thesis, too, may be exaggerated. Many of the connections and analogies he insists on may be strained and improbable, and some of them downright ridiculous. (I have seen it claimed, for instance, that Newton's theory of the plan-etary system was a reflection in physics of the constitu-tional order set up in Britain after the Glorious Revolution of 1688. To accept this view would be to make needless work for Professor Rhine and the parapsychologists; for Newton's *Principia* was already in print in 1687, preceding

the event it was alleged to reflect by a good year or more.)
Yet the fact remains that some of the Enthusiast's claims
are undoubtedly genuine, so that one must set about criti-
cizing his assertions in detail, rather than dismissing his
entire thesis as ridiculous. And this one can do only given
some sort of test, some sort of criterion, for telling the
possible from the impossible, the reasonable from the ab-
surd. Our question is: what sort of criterion could this be?

However, until we understand better than we do all the
channels by which art and science, music and politics exert
an influence on one another, we shall not be in a position
fully to sort out sound theories from unsound ones, or sig-
nificant parallels from coincidences. We shall remain, in
fact, in a position like that of the ancient cosmologists and
astrologers. They saw things in the heavens and things on
the earth changing in cycles, in step, in rhythm with one
another. But since they did not understand how these things
come to happen as they do, they were at a loss to sort out
significant correlations from others. The tides of the sea, for
example, followed the same cycles as the phases of the
moon; but so also did the physiological cycles of women;
and some weak-minded men had recurrent fits with the
coming of each full moon, and were christened lunatics
as a result.

Lacking explanations of these things, men thought of
the cosmos as a system of harmoniously-ordered parts, in
which the changing aspects of one part could be read as
clues to the changes which would affect others also. Eclip-
ses in one quarter of the Zodiac, argued Ptolemy, should
affect the political fortunes of countries in the correspond-
ing quarter of the inhabited world. Changes in the seven

chief heavenly bodies (the macrocosm) were likewise mir-
rored in the seven principal parts of the human frame
(the microcosm), the seven metals, and all other sevens.
Astrology in those days was in principle neither better nor
worse than meteorology or the prediction of the tides. In
each case the mechanisms involved were obscure; and once
one admitted that the moon acted directly on the oceans,
it was hard—while one lacked a theory of gravitational
pull—to disprove the claim that it could act similarly on
madmen or women or politicians.

Today, of course, the prediction of eclipses or spring
tides seems to us intellectually respectable in a way that
personal and political astrology do not. But this is because
we have the advantage of living after Newton: we grow
up learning to take the triumphs of Newton's dynamics
for granted. And with our better understanding, which
has come during the last two and a half centuries, of the
ways in which the heavens can possibly act on the earth,
we have a criterion, of a kind Newton's predecessors never
had, for sorting out the grain from the chaff in earlier
ideas—for distinguishing authentic cases of lunar influence,
such as the pull which causes the tides, from other, less
well-founded astrological claims.

In the history of art, culture, and ideas, we are not yet
in this position. The idea that the arts and science change
in step according to a Spirit of the Times may be no better
than the theory that the microcosm and macrocosm change
in sympathy with one another. But it is no worse than that
theory, either. Perhaps it is just a way of rationalizing par-
allels that we are not yet in a position to explain. But many
of the parallels are genuine, and we shall see which of

17

them are only through a proper analysis of "intellectual dynamics": that is, through an understanding of the processes by which cultural and intellectual changes in one field of activity come to produce changes in ideas, styles, or techniques in other Arts, Sciences, . . . or Dodges.

There are, as I see it, four distinct credible ways in which the various arts and sciences react on one another. Three of them I understand well enough, the fourth is to me still somewhat mysterious. The first two are direct intellectual ones, and only the second is really our concern here.

i. One natural science can influence another when the first science provides the intellectual tools needed for solving problems in the second. Lavoisier, for instance, used certain fundamentally physical ideas to solve problems in chemistry, and Liebig in turn used chemical ideas for solving physiological problems. This sort of thing happened in the seventeenth century, as at any other time. Advances in physics between 1675 and 1700 owed a lot to improvements in mathematics dating from earlier in the century. But this is something of domestic concern to the history of science, so we can leave it at that.

ii. The second kind of interaction is also an intellectual one, and Professor Bush will be saying a good deal about it in his essay. For the striking thing about the literature of the seventeenth century, and especially about English poetry, is the speed with which the content of seventeenth century science influenced the subject matter of literature. The astronomical discoveries of Galileo struck the thinkers and writers of Europe like a shaft of lightning. Galileo

in 1610 gave an account of his new discoveries with the telescope in his little book, *The Starry Messenger*. Within a few months of its publication, knowledge of his work had spread all over Europe, and within five years the book was being read as far away as Peking. This lightning spread of the new astronomy is something almost without parallel. Even Tennyson did not respond as quickly to Darwin as the seventeenth century poets did to Galileo. As for the literary fads of relativity and psychoanalysis in the 1920's, these showed far less understanding of Einstein and Freud than Milton, for instance, had shown of the implications of the new cosmology. It has usually taken a full generation for a novel idea in natural science to become a commonplace of literature, and the same is true of the influence which the physical sciences have had on politics and social thought. Political and social theory began to model themselves seriously on Newton's physics only fifty years after the publication of the *Principia*.

Astronomy apart, then, the ideas expressed in seventeenth century literature look back for the most part to earlier times. Jonathan Swift was well aware of what the *virtuosi* of the Royal Society were up to, and showed in *Gulliver's Travels* how much he disliked and despised it; but even John Donne (whose debt to the new astronomy was considerable) drew most of his scientific imagery and ideas about nature from much older sources. His "dull sublunary lovers" who "must like chimney sweepers come to dust," as well as the "vegetable loves" of Andrew Marvell, are relics of Aristotelian cosmology and biology. As for the Newtonian theory of motion and gravitation, this took twenty years or more to make its way in physics, so

that the story of Newton's impact on literature is, not surprisingly, an eighteenth century one.

III. There is one further clear way in which developments in the natural sciences have influenced the arts. This has to do, not with the ideas expressed in the arts, but with the techniques, devices, and styles employed by the artists. If the best examples of direct intellectual influence come from literature, the best examples of stylistic influence come from painting and architecture, for there the intellectual and literary elements play so much smaller a part. Republication of mathematical works by Archimedes and Apollonios of Perga in the sixteenth century not only gave a great fillip to the development of European mathematics, but drew the attention of architects to a whole new range of possibilities: Apollonios' "conic sections"—for instance, the ellipse—began to appear seriously in European architecture for the first time, notably in the designs of Guarino Guarini. There was, of course, no necessity for them to do so; but the idea of handling conic sections was novel and intriguing, and the new mathematics made it possible to describe and construct them more simply than before. This technical innovation was in no sense a necessary consequence of the new mathematics: the mathematics simply dropped a hint, a suggestion, of an architectural possibility hitherto overlooked.

In a similar way, the late nineteenth century Neo-Impressionist painters in France used to appeal to the physical theory of the spectrum and the physiological theory of vision to justify their ideas about pure color in painting: there, too, the scientific ideas simply served as a hint to the artist. Unlike a man designing, say, achromatic binoc-

ulars, who might well appeal to optical theory to prove the soundness of his design, the Impressionist painters could justify their techniques only by appeal to the onlooker, not to physics. And the same is true in our own day, when, for instance, the English painter Ivon Hitchens appeals to the theories of Einstein to explain his ways of producing effects of depth. Such appeals may not be without point. Hitchens has thrown away the whole apparatus of converging lines, geometrical coordinates, and vanishing points which the classical tradition had built up so carefully on the pioneer work of Dürer, Piero della Francesca, and Leonardo da Vinci. In place of these traditional devices, he juxtaposes colors having different degrees of intensity and saturation to produce visual effects of relative depth and relative distance. And this rejection of classical perspective, which depended on building a preferred geometrical frame of reference into the design of one's picture, might certainly have been suggested by reading popular accounts of Einstein's similar step in physics. But the operative word is still "suggested"; in the field of aesthetic techniques, Einstein's theories had of course no direct implications.

Only in the field of architecture does the influence of science on technique go very much further. For architecture can be regarded as a branch of engineering, and is therefore a technology or applied science in a way that music and painting scarcely are. Indeed, when Galileo wrote his famous treatise *On Two New Sciences*, one of them was concerned with a subject of direct importance to architects: the strength of materials and the breaking points of beams.

IV. So much for three obvious ways in which different sciences and arts can interact. I said earlier that the fourth and last of these kinds of interactions struck me as the least intelligible, and this I must repeat. The influence of Galileo on Newton, or of Newton on Lavoisier, one can understand. The influence of Galileo on Milton, or of the founders of the Royal Society on Jonathan Swift, these one can well understand, too, as one can the influence of Newton's *Optics* on the French Impressionists, or of Apollonios of Perga on an architect like Guarini. In each case, the way in which the influence is exerted is clear, and makes sense—books passing from hand to hand, being read with greater or less attention, discussed with more or less intelligence; some exciting new ideas having an impact within a year or two, others making their way more slowly and having a delayed effect.

But there are more resemblances and connections between the arts and sciences of any particular age than can be explained in these three ways alone. And though my natural inclination in a situation like this is to be a bit tough-minded and sceptical, I must curb my impatience and state the facts for what they are. It does seem exaggerated, of course, to suggest that painters and mathematicians and musical composers and architects and theologians are all going to work in similar ways just because they all happen to be living in the seventeenth century, or the twentieth century, or whenever it may be; if their works do show parallels, something, one feels, must be keeping them working in the same direction. But remember: Leibniz felt the same impatience with Newton's idea of gravitation and dismissed it as "a perpetual miracle," finding it incredible

that the sun should pull on the earth and cause it to move in a curve, unless he could be shown the intervening chain of pushes-and-pulls bridging the gap between them. The first thing is to see what in fact happens: it is no good denying the facts just because we are not yet able to think up a mechanism to explain them.

We can, in any case, appeal for support to the towering authority of that great and critical scholar, Professor A. O. Lovejoy. He has written about precisely the sort of intellectual phenomena I have in mind—for instance, in his paper on the analogies between deism and classicism in the eighteenth century. At some points, he observes, one finds in seemingly unrelated fields of thought and art a convergence of ideals and a similarity of tastes. To admit this is not to let the *Zeitgeist* in again by a back door, for he has at any rate the beginnings of an explanation for the kind of case he is writing about. Certain leading ideas, certain presuppositions and tastes, often operating through fashionable but highly ambiguous words like nature or reason, can, he argues, help to spread similar intellectual prejudices between quite diverse provinces of thought, and may limit the range of views which men are prepared to accept as intellectually respectable. Think, for instance, how widespread was men's admiration for the Noble Savage in the days when the first seedlings of the Romantic Movement were springing. Even within the natural sciences, one can add, the reign of the "o.k. word" and the acceptable style can prove as demanding as elsewhere. The emanations of one century become the subtle fluids of the next, to reappear as fields in a third century and as mathe-

matical functions in a fourth, as much at the dictates of fashion as under the compulsion of the facts.

These convergences in style and taste, of which Professor Lovejoy writes, may sometimes have other origins. It can hardly be a pure coincidence that the early twentieth century was the period of atonal music and nonrepresentational painting, as well as of formalist mathematics. It is surely not just visionary to see a genuine parallel here. Yet in this particular example, maybe we should look for the explanation of any analogies not so much in the direction of Lovejoy's "leading ideas" as in social factors, such as the changing system of artistic and scholarly patronage. For, of course, if there is a ready market for icons, painters will paint saints; or merchants' wives, or landscapes, or race horses. And if there is no longer a supply of patrons with specific kinds of demands, the painters will be left to themselves, and will simply paint. And an era with a shortage of patrons for the fine arts may also, for economic or social reasons, be an era in which original composition in music and creative thought in mathematics are also short of a market. The whole issue is obviously far more complex than that, but I throw this much out for what it is worth. At any rate, this fourth class of parallels and resemblances, even if it is no longer mysterious, may well turn out to be rather a mixed bag, in which different kinds of cases call for different kinds of explanation.

I have made this essay an occasion for talking in a broad way about the interaction between science and the arts, not just in the seventeenth century, but in general. The time has now come to go back and take up again some of the

questions I mentioned at the outset, to draw the threads of my essay together. Our subject is the scientific revolution and its influence. This revolution I have said was a complex phenomenon, which affected the arts in several different ways. But there is one aspect of it about which I have not yet spoken, and when we take this into account the whole perspective of our picture may change. For the chief spokesmen of the scientific revolution thought of themselves as inaugurating a revolution in intellectual *method*. I refer to two men who were very different figures in some ways, but allies in this particular campaign: Francis Bacon and René Descartes. In looking at cultural changes in the seventeenth century, one has to ask not just about the impact of the new astronomy and dynamics, but also about the influence of this proposed new method, with its emphasis on mathematics and experiment.

In the event, the new program for science paid off more quickly in some sciences than in others. The crucial step for physics was the publication in 1687 of Isaac Newton's *Principia*, and the new science of the seventeenth century, as I have explained, did not extend much beyond mathematics, physics, and astronomy. The corresponding steps in chemistry and physiology were delayed. Lavoisier and Dalton, working either side of 1800, were to be the joint Newtons of chemistry; and physiology was not really launched until the second half of the nineteenth century. Yet I wonder how far, in the seventeenth century, the wider influence of science owed anything very much to the new principles of method. Even today the tools and instruments of science, such as the electronic computer, tend to catch the attention of the amateur in a way that Heisen-

berg's theories or the principles of methodology cannot hope to do. So in the seventeenth century also: the great stimulants to the imagination of the time were the telescope and the microscope, and these might well have come, whether or not Bacon and Descartes had ever written.

Men looked up at the sky through the telescope and found that the supposed limits of their world were only the limits of their unaided vision. It took some time for them to become accustomed to this new scale and proportion. Yet the change of scale which took place in men's thinking about space and the size of the universe did not immediately take place in their thoughts about time also: people were never more convinced than in the seventeenth century that the creation of all things had happened only a few thousand years ago. The transformation of scale in our vision of the world which Galileo began was completed only in the nineteenth century by the geologists, who at last put it beyond doubt that the history of the world stretched back for millions of years—many, many times as far as the five or six thousand years one might infer from a literal-minded reading of the genealogical chapters in the Bible.

The microscope, just as much as the telescope, captured people's fancy and left its mark on English literature. But unlike the telescope, it did not lead at once to the same sort of dramatic changes in science itself. Robert Hooke, it is true, did begin to study the cellular structure of plants, and the Italian physiologist Malpighi was able to observe directly the capillaries which Harvey had postulated in order to complete the circulation of the blood. But the great age of the microscope came only 150 years later,

with the invention of the compound objective. Until then, the study of animalcula and cheese-mites was little more than a scientific curiosity: microbiology proper, still more the cell theory, remained for the future.

In seventeenth century natural history and geology, again, there may have been a new tone, but this came more from theological innovations than from scientific discoveries. There was a fresh taste for natural theology in English Protestantism, and a new reliance on the argument from design: John Ray found *The Wisdom of God* manifested in the living creatures of nature, and Thomas Burnet wrote about geology as *The Sacred Theory of the Earth.*

Swift's brief summary of what seventeenth century science meant to him consists of three words: Lilliput, Brobdingnag, Laputa—the microscope, the telescope, and the Royal Society—and this is perhaps as good a summary as one can give of the impact science had on the public mind of the time. If we look on, past 1700, into the eighteenth and nineteenth centuries, we shall find that in the longer run the most influential thing proved to be, not the content of seventeenth century science, but the program of seventeenth century philosophy. The atomic theory of Robert Boyle was still firmly rooted in philosophy. Locke's vision of a world in which the color, warmth, and other secondary qualities of things would be explained in terms of the sizes, shapes, and motions of their constituent atoms was to bear rich scientific fruit in the 1800's, with the combination of Dalton's chemical atomism and the kinetic theory of matter. As for Descartes' ideal of a completely mechanistic physiology, this had still longer to wait, and is only partly realized even today.

27

Stephen Toulmin

I started with one large, easily-stated question about the influence of seventeenth century science on literature, music, and the arts. I have broken this down into a larger number of individually-smaller questions, about the ways in which half a dozen natural sciences had their effect on as many fine arts and fields of literature. In the course of the dissection I have issued more IOU's than succeeding essays can seriously be expected to redeem. But in a subject as complex as this one, there is no harm in equipping one's intellectual dovecote with more pigeonholes than one yet has pigeons. In this way, something else besides one's own oversimplified theories will have a place to roost.

Note

This essay is an attempt to draw together a number of intellectual threads from different academic disciplines. My debts to scholars working in the history of science, arts, and ideas will be obvious. Let me mention specifically Dr. A. O. Lovejoy and Dr. Marjorie Nicolson.

Science and Literature

DOUGLAS BUSH

D URING the nineteenth century the great watershed be- tween the medieval and the modern era was com- monly taken to be the Renaissance of the fifteenth and six- teenth centuries. In our time the watershed has been moved up to the seventeenth century "Enlightenment." In this large change of focus the history of science has played a large role.

Professor Toulmin has suggestively outlined the com- plex effects of the scientific revolution upon the human- ities. In dealing with literature one would need, even if one were writing a book instead of an essay, to begin with some provisos. First, since the body of significant English literature is itself far too big to cope with, one cannot bring in continental as well; but, so far as my knowledge goes, no national literature of the continent surpasses Eng- lish in its responsiveness to science. Secondly, although science was one important factor in the distinctive change of style in prose and verse, we shall be looking mainly at the basic effects on belief and thought and sensibility of which style is the outward manifestation. Thirdly, while science is our theme, we should never forget that old cer- titudes were being undermined by other powerful forces, from the Reformation and sectarian divisions to the re- vival of ancient philosophic scepticism, along with the prob-

DOUGLAS BUSH is Gurney Professor of English Literature at Harvard University. His books include two cited in the appended bibliography.

lems that afflict people in every age. Finally, though we cannot avoid generalizing about tendencies and attitudes, all generalities must be understood as limited and qualified. We cannot talk about "the seventeenth century mind" any more than we can about "the twentieth century mind," since in any period such a label covers a wide spectrum of variations. (I might add that I shall never, except now, use the word "baroque.") Moreover, within an individual mind of the seventeenth—or twentieth—century there normally co-exist beliefs and attitudes, old and new, which to posterity appear incompatible; two eminent exemplars of such mixtures are Bacon and Descartes, and a list would include almost every scientist and thinker and writer as well as the crowd of men in the street.

From the mid-sixteenth century onward, English scientists and mathematicians were, in their number, genius, and variety of achievement, a conspicuous part of the European vanguard; the more or less illustrious names run from Robert Recorde, John Dee, Thomas Digges, Thomas Harriot, William Gilbert, John Napier, William Harvey, and Bacon, up to Robert Boyle, Robert Hooke, John Ray, and Sir Isaac Newton. Latin was still the international language, so that there was osmosis, public and private, between English and continental scientists. Along with experiment and speculation of all kinds, the telescope and later the microscope immensely enlarged the range of observation; some old notions were killed and some new ones established. Behind the manifold discoveries in celestial and terrestrial nature were diverse motives. One was the pressure of technological needs in everyday work and production, from mining to navigation. Another was

the shift of inquiry from final to secondary causes, from the metaphysical and religious question "Why?" to the scientific question "How?", from abstract theory to measurement. That shift, we may remember, had been made by a number of minds in the later Middle Ages.

Seventeenth century England yielded a large bulk of more or less scientific writing that is more or less important in the history of ideas, but none of it belongs to great literature except that of Bacon (and Burton, if we count him as a scientist). Though Bacon did not of course invent experimentation, he was the herald and prophet of the experimental method and the gospel of scientific and technological progress. *The Advancement of Learning* (1605) is such a landmark, such a majestic *Summa*, in intellectual history, and such a monument of English prose, that a few things must be said about it. While physical science was only one major area in Bacon's stocktaking of the whole field of knowledge, his general criteria were those of a scientific positivist. The three chief "vanities" of learning that have hindered progress—literary and stylistic education, scholastic logic, and such pseudo-sciences as astrology and alchemy—receive the censure of a Jacobean John Dewey (though Bacon's prose is far from Dewey's). His condescending view of most poetry as escapist fantasy has been that of a good many later scientists and philosophers. History and ethics likewise need to be realistic; Machiavelli has set the wholesome example of showing what men do, not what they ought to do. Passages in the *Advancement* give concrete clues to the purpose of Bacon's essays, most of which were still to come: these would supply the lack of realistic psychological studies of the be-

havior of men of affairs. Finally, science has been confused and misguided, ever since Plato, by being mixed with theology, and the two realms of knowledge and faith must be kept separate; while Bacon was, according to his light, a good Christian, his concern here and elsewhere seems to be the protection and progress of science, which is more in danger than religion. In all this critical, empirical realism we see the beginnings of the temper that was in no long time to dominate thought and literature.

Bacon also urged the need of plain, precise writing in scientific exposition, and in this as in other things he was to be followed by the Royal Society. But when he wrote the *Advancement* and a number of other philosophic works, and the *Essays*, he was not rigidly bound by such principles. If we compare his writing with that of Gilbert or Harvey or later scientists, we find less scientific bareness than massive plenitude and a figurative, even a poetic, strain.

Bacon's place in the history of scientific thought is too well known to need discussion, though he has suffered a good deal from wrong-headed and repetitive disparagement. At any rate, both English and continental scientists of his century paid full tribute not only to his leadership and inspiring program but to his grasp of scientific method. (One dissenter was his personal physician, Dr. Harvey.) However, while Bacon was a great seminal mind and a great master of prose, it is clear that his philosophic writings exist for us only or mainly as documents in intellectual history—whereas Sir Thomas Browne, with all his aberrations, we read and cherish as a living classic.

Whether or not the young Milton had yet read Bacon,

his last public speech at Cambridge (1631-32?) was in part an ardent Baconian vision of man's achieving godlike control of the forces of nature. Abraham Cowley, who had made a name as a metaphysical lyrist of love, in an unfinished epic on King David planted a Baconian college in ancient Judea. But the conspicuous heirs of Bacon were the members of the Royal Society, who were creating a "Salomon's House," an institute of cooperative research, in the spirit of *The New Atlantis*. Some of the founders began to meet about 1645, during the civil war, though the Society was not formally organized until 1662. In the Restoration period it included working scientists and amateurs and men like Pepys and Evelyn and Dryden —a reminder that science had come to be a serious and fashionable interest of laymen. Cowley's ode *To the Royal Society* saluted Bacon, in a fitting and famous figure, as the Moses who had led mankind to the edge of the promised land. For a general testimony to the ever-growing consciousness of progress we might quote such a pure man of letters as Dryden (*Essay of Dramatic Poesy*, 1668):

"Is it not evident, in these last hundred years (when the Study of Philosophy has been the business of all the Virtuosi in Christendome), that almost a new Nature has been reveal'd to us? that more errours of the School have been detected, more useful Experiments in Philosophy have been made, more Noble Secrets in Opticks, Medicine, Anatomy, Astronomy, discover'd, than in all those credulous and doting Ages from Aristotle to us? so true it is, that nothing spreads more fast than Science, when rightly and generally cultivated."

Along with Dryden's well-founded testimony to prog-

33

ress, we might recall a book that illustrates a not untypical blend of old and new, Sir Thomas Browne's *Pseudodoxia Epidemica* or *Vulgar Errors*, which first appeared in 1646 and had revised editions beyond the date of Dryden's *Essay*. In Browne's opening account of the common causes of error, the Baconian critical spirit is mixed with Brownesque piety and antiquarianism. In most of the work he was providing what Bacon had called for, a natural history that would sift truth from the traditional lore of centuries, and he used observation and experiment when he could. When he could not, he weighed reason and authority, as in proving that elephants' legs have joints; we may be further surprised by the reasoning brought to bear on the supposed inequality of a badger's legs. Browne was in many respects a true and zealous scientist (he had had the best medical training Europe afforded, and he thought Harvey a greater discoverer than Columbus), but the reverent wonder that inspires his finest writing is more religious than scientific. Most of his problems do not, as many of Bacon's and the Royal Society's do, look forward to the industrial revolution, though the *Pseudodoxia* is much more inviting than most of the books that propagated the gospel of scientific progress, such as Sprat's *History of the Royal Society* (1667).

With full recognition of the rapid growth and dazzling achievements of science in the seventeenth century, we must keep in mind our proper subject, literature; and a good deal of that was less optimistic than the literature of science, for its serious authors seldom forgot man's fallen state, from which science would not raise him.

Throughout the century the strongest impact on thought

and literature came from astronomy and cosmology, and we shall follow that main line. But first we may glance at the pseudo-sciences of alchemy and astrology which Bacon had put among the chief obstacles in the way of true science, and which had indeed a revival in Europe in the sixteenth and the early seventeenth centuries. They illustrate the twilight that hovers over man's transition from the old world of the mind to the new, and also the quite legitimate way in which—in the spirit of alchemy —living metaphors might emerge from dead bodies of science.

The quest of the philosopher's stone, which could transform the baser metals into gold, had been laughed at by Chaucer, and it could be used by Ben Jonson for one of his satirical exposures of knavery and greed. An agent for transmuting metals, a magical elixir for bodily ills, and, on higher levels, a religious creed of cloudy mysticism—these ideas were still alive, but they had largely given way to genuine chemistry, at first as the rational search for new medical drugs and then in its broad modern sense. On the scientific side it may be added that alchemy had been a real "prelude to chemistry," and that the notion of transmuting elements could rightly attract scientific minds from Bacon to Boyle and Newton; a partly similar idea has been a reality for modern science. A second point, closer to our present concern, is that both the basic principle and its offshoots grew out of the universal belief in the divine unity of the whole creation. Thirdly, the old occult notions continued to yield abundant images and metaphors which had their own imaginative and emotional validity.

An example of the simplest kind would be Shakespeare's glorious morning "Gilding pale streams with heavenly alchemy." But "scientific" complexity fills a passage near the end of Book III of *Paradise Lost,* where Satan's alighting on the sun leads Milton to gather up all that man had ever thought and felt about the source of light and life. In his description of the alchemists' vain endeavors—which, Kester Svendsen remarks, carries a judgment on self-deceiving pride akin to Satan's—the main ideas come through to the uninformed reader, as they usually do in Milton's technical passages, with almost unimpaired force and with a touch of suggestive mystery. But Donne's *Nocturnall upon S. Lucies Day,* while it tells the uninformed reader that the poet feels annihilated by grief, has a texture that is hardly intelligible without knowledge of alchemical and especially Paracelsian doctrines. Of all poets of the century, Donne had perhaps the most up-to-date stock of scientific information; he was also the most addicted to alchemical language and images, though seldom with the sustained density we have in this poem.

Our second pseudo-science, astrology, was, as Kepler said, the foolish little daughter of the respectable, reasonable mother, astronomy; yet Kepler, the great mathematical lawgiver of early modern astronomy, not only was an astrologer himself but associated ideas of the Trinity with the solar system. While in England many condemned judicial or prophetic astrology as spurious, unlawful, or sinful, it was the common moderate view that the stars exerted an influence upon terrestrial nature and the constitution and hence the destiny of man; in Robert Burton's phrase, the stars "do incline, but not compel." Here again,

age-old ideas and metaphors attended and outlived positive belief. The young Milton saw animate Nature awaiting the incarnation of her Creator, the stars "Bending one way their pretious influence"; the old Milton, picturing the effects of man's sin upon nature, described the "noxious efficacie" of planetary motions and aspects and the "influence malignant" of the stars. Andrew Marvell could give astrology a high tragic ring:

> Therefore the Love which us doth bind,
> But Fate so enviously debarrs,
> Is the Conjunction of the Mind,
> And Opposition of the Stars.

Along with astrology may be mentioned the general belief in natural portents, meteors, comets, eclipses, which is commonly used by Shakespeare, and which inspires that grandly ominous simile in Milton where the sun

> from behind the Moon
> In dim Eclips disastrous twilight sheds
> On half the Nations, and with fear of change
> Perplexes Monarchs.

We may recall here too the Pythagorean-Platonic notion of the music of the spheres, which was evidently as familiar to an Elizabethan theatre audience as less beautiful Freudian ideas are now, since the most famous allusion is in the moonlight dialogue of Lorenzo and Jessica:

> There's not the smallest orb which thou behold'st
> But in his motion like an angel sings,

37

Still quiring to the young-ey'd cherubins;
Such harmony is in immortal souls;
But, whilst this muddy vesture of decay
Doth grossly close it in, we cannot hear it.

To take another bifocal glance at Milton, in the *Nativity* the music of the spheres is linked with the music of the angels as a symbol of cosmic harmony; and in *Paradise Lost* the poet is kindled to half-mystical rapture by the more astronomical image of the starry dance, the irregular regularity of the planetary orbits.

Before we ask how the new astronomy affected the seventeenth century, we must ask what was there to be affected, what traditional ways of belief, thought, and feeling constituted the normal world-view. That world-view has been so often described in recent years that an oversimplified summary will serve. In the Aristotelian-Ptolemaic cosmos the central, stationary earth was surrounded by layers of the other three elements, water, air, and fire; outside these were the spheres of the moon, Mercury, Venus, the sun, Mars, Jupiter, Saturn, and the eighth sphere of fixed stars, all being kept in motion by an outermost ninth or tenth sphere, the *primum mobile*. This and all that went with it were founded on Christian belief in the unity and order of the whole creation. The world of nature, from the spheres to the seasons, operates under the reign of law, divine, prescientific law. It was created to minister to man, and the vast firmament revolves about the earth to give him light and darkness— "The starres," says George Herbert, "have us to bed." The great chain of being descends from God through

angels, man, animals, plants, and nongrowing matter. All creatures and things have their place in the grand hierarchical pattern, from the classes of angels and of society to the rational and irrational faculties of man's mind. Man, occupying a station midway between the beasts and the angels, is pulled both downward and upward by the warring elements in his own nature. As a being of mind and body, he is the microcosmic parallel to God and the universe. "I am a little world made cunningly," says Donne, "Of Elements, and an Angelike spright"; and Ralegh in his *History of the World* and Donne in his *Devotions* (Meditation iv) draw out the likenesses between man's veins and rivers, and so on. All creatures and things and ideas in the world are linked with one another by analogy and correspondence. In reading metaphysical and other poetry we are often more surprised than we should be at the yoking together of apparently unrelated things; they were not unrelated. And finally as well as first, man and his world are God's creation and under His immediate and providential governance; man's life on earth is only a prelude to eternal bliss or torment. We may remember the two lines that follow the two just quoted from Donne's sonnet:

But black sinne hath betraid to endlesse night
My worlds both parts, and (oh) both parts must die.

Even on earth man is surrounded by good and evil spirits, the ministers of God and Satan; Burton describes both kinds, but only the good are known to Milton's innocent Adam:

Douglas Bush

Millions of spiritual Creatures walk the Earth
Unseen, both when we wake, and when we sleep.

This classical-Christian world-picture had been built up
over many centuries, out of traditional philosophy, reli-
gion, and the senses and imagination; and, at least in its
prime essentials, it was shared by learned and unlearned
alike, by Hooker and by Shakespeare. Man could be bes-
tial more often than angelic, but he was God's creature in
a world rich in meaning. He knew, if he did not always
remember, that he was daily enacting under the divine
eye the supreme drama of salvation or damnation. Every-
day life was a variegated web of the brutal and the miracu-
lous. To stress only one thing, it was an ideal world for the
writer, the poet, a world of crude, harsh, and tragic actu-
ality enveloped in religion and myth and "magic"; human
experience and language and image and symbol compre-
hended the widest and deepest range of significance and
contrast. It is no wonder that the late sixteenth and the
earlier seventeenth century were the golden age of Eng-
lish poetry and prose. For one of countless reminders,
there is Sir Thomas Browne, who, though a scientist, is
a superb mid-century exemplar of the old religious and
symbolic conceptions of God, nature, and man. *Urn-Burial*
and *The Garden of Cyrus* (1658) are, as F. L. Huntley
has shown, twin meditations, intersecting circles. The fu-
neral urn has the shape of the womb, and death is "the
Lucina of life." Browne's Christian-Platonic imagination
works out the parallels and contrasts between death and
life, body and soul, matter and form, time and space;
these and other opposed concepts come together only in

the mind of God, in Eternity and Unity, where darkness and light are one. When we read such things, in language and rhythms that only Browne can command, we may feel that his vision has more reality than all the measurements of the new physics, which belonged to another dimension than the "mysticall Mathematicks of the City of Heaven." Browne's is the world of natural and supernatural order and process, of analogy and "myth" and hieroglyphic—and a large part of our subject here is what Marjorie Nicolson has called "the breaking of the circle."

It took well over a century for the Copernican theory, in spite of the work of Kepler, Galileo, and Elizabethan experts, to win full acceptance even among the learned. In 1643, exactly a hundred years after Copernicus' book, Browne the scientist named the moving of the earth among manifest impossibilities—though his considered position was a not unscientific agnosticism. The reasons for retarded victory were natural. Many learned as well as unlearned men resisted contradiction of the senses and the Bible or of Aristotle, Ptolemy, and all tradition. Many were simply unaware or indifferent, as most of us felt no acute concern over Einstein's discoveries. In both cases few had the mathematical knowledge needed for comprehension or confirmation; indeed the knowledge needed to confirm Copernicus was not fully available until Newton. Also, while Ptolemy "saved the appearances" no less, though less neatly, than Copernicus, the latter in the seventeenth century had a stronger rival in the theory developed by the first great modern observer, the Danish Tycho Brahe, a compromise which attracted men not quite ready to swallow Copernicus. According to this theory, the earth re-

mained the stationary center of the orbits of the moon, sun, and sphere of fixed stars, and the five planets revolved about the revolving sun. For example, Donne seems to have been a Tychonist; at any rate, though he was well aware of Copernicus, Kepler, and Galileo, he commonly alluded, even in his later verse and prose, to a moving sun and motionless earth. Milton indicated knowledge of the Copernican—not of the Tychonic—system, but used the Aristotelian-Ptolemaic one (which was only a small bit of his imagined universe), presumably because he was uncertain, because it was the familiar conception, and because it kept earth and man at the focal center of the cosmic scene. But Milton was of the new age in his imaginative rendering of immense space.

When we consider, abstractly, the effect on thought and literature of the Copernican view of the world, we are likely to slip into fallacious exaggeration. It is often said that the dislodging of the earth from its central place in a comfortably ordered system to the status of a minor planet in vaster space was a fatal blow to man's sense of his own dignity, of his prime rank in creation. This idea, as R. G. Collingwood says, is philosophically foolish and historically false. Throughout the Middle Ages, even though man was the uniquely endowed child of God, the earth was regarded as the basest part of creation. Copernicus himself was no cosmic iconoclast; he was only looking for a simpler pattern of the heavens than Ptolemy's, and he found it. When Thomas Digges, the Elizabethan Copernican, contemplating a universe he saw as infinite, speaks of "this little darcke starre wherein we live," we expect him to continue in the vein of, say, Thomas Hardy or

Bertrand Russell; but, for Digges, the enlargement of the universe only enlarges the glory of its Creator and does not degrade man. And this general attitude persisted among scientists, such as the earnestly religious Boyle and Newton, who upheld God's continuous control of the cosmic order. Indeed, a number of the lesser Copernicans were clergymen, for example, John Wilkins, a champion of the new science and the moving spirit in the formation of the Royal Society. When the moral poet Samuel Daniel, or the physician-lyrist-composer Thomas Campion, or the religious poet George Herbert, or Sir Thomas Browne referred to the earth as a mere point in space (as many others had done, from Cicero and Boethius onward), it was to illustrate the greatness of man's mind, or mutability, or patience in affliction, or some other lesson as old as thought. Shakespeare, if aware of the new astronomy, seems to have been wholly indifferent; and knowledge could hardly have enriched his power over word and rhythm or deepened his insight into human experience, unless perhaps it might have added a cosmic shiver to Hamlet's questionings. But as everyone knows, Hamlet, apart from his private griefs, recognizes the glory of earth and man; and Ulysses' speech in *Troilus and Cressida* (I. iii) is the poetical *locus classicus* for the doctrine of order and degree in the great chain of being.

The Copernican theory seems to have been less disquieting than other discoveries and ideas that were launched or revived along with the new astronomy. Gilbert's argument for the daily rotation of the magnetic earth on its axis received ready scientific approval. But the appearance of new stars in 1572 and 1604 and Galileo's telescopic

observations were concrete facts which contradicted the Aristotelian-Christian belief that, whereas the region be-low the moon was subject to change, the ethereal region beyond was immutable. Yet the old conception lived on as a symbol at least of purity and stability above earthly flux. Donne contrasted the bond between himself and his wife with "Dull sublunary lovers love," a thing of sense, and Sir Thomas Browne, reflecting on the vanity of earthly monuments, saw no "hope for Immortality, or any patent from oblivion, in preservations below the Moon."

Then there was the revived idea of a plurality of in-habited worlds, an idea that intoxicated Giordano Bruno, and later Henry More, but might disturb others. In the most elaborate contemporary survey of astronomical and cosmological theories, in the *Anatomy of Melancholy*, Robert Burton includes the question whether people in other worlds would have souls to be saved. Yet the devout Burton, though deeply compassionate for the varied suf-ferings of man, seems to be less troubled than amused by astronomy; the thousand bewildering questions will be answered in God's good time. Donne, in his earliest extant sermon, declares that "one of our souls is worth more than the whole world" and that one drop of Christ's blood would be "sufficient for all the souls of 1000 worlds." *Paradise Lost* has several references to the possibility of other worlds, but Milton is untroubled, except by the prac-tice of all such remote speculation if it diverts prideful man from the true ends of life. And while the religious and scientific Pascal was appalled by the eternal silence of infinite space, for the religious poet—as for the reli-

gious and scientific thinker, Henry More—there were no terrors in vast space that God fills.

But Milton linked man's fall with the transformation of idyllic Eden into the harsh natural world we know, and that symbolic picture may take us back to a traditional belief which became especially prominent in the late sixteenth and the earlier seventeenth century. It might be called a sort of equivalent of the second law of thermodynamics: nature, including man, had lost its original vitality and was decaying toward its ultimate dissolution. The most voluminous arguments came from two clerics. In *The Fall of Man* (1616) Godfrey Goodman might be said to have combined the themes of Donne's two *Anniversaries*; he stressed the fall and continued sinfulness of man, from which came the corruption of nature, the macrocosm, and he saw no hope except in God's grace and renewed faith. In 1627 and later, George Hakewill, replying to Goodman and the general chorus, saw no evidence of decay except in man's failure of nerve; if roused to resolute activity, he could go forward. The debate is one landmark in the division between pessimists and multiplying progressives. In a short Latin poem the young Milton, as we might expect, repudiated the notion of decay.

A second belief, often connected with the first but less involved with science, was that the world would end six thousand years after its creation; hence, in the early 1600s, man had come more than three fourths of the way through the third and last period of historical time. This idea is perhaps most familiar in one of the richest passages in Donne's sermons (a sermon preached at Whitehall, April 18, 1626), where he uses it in the effort to make conceiv-

45

able to finite minds the meaning of eternity. The quoting
of this is an indulgence, but it will be forgiven.

"*Qui nec praeceditur hesterno, nec excluditur crastino*, A
day that hath no *pridie*, nor *postridie*, yesterday doth not
usher it in, nor to morrow shall not drive it out. Methu-
salem, with all his hundreds of yeares, was but a Mush-
rome of a nights growth, to this day, And all the foure
Monarchies, with all their thousands of yeares, And all
the powerfull Kings, and all the beautifull Queenes of
this world, were but as a bed of flowers, some gathered
at six, some at seaven, some at eight, All in one Morning,
in respect of this Day. In all the two thousand yeares of
Nature, before the Law given by Moses, And the two
thousand yeares of Law, before the Gospel given by Christ,
And the two thousand of Grace, which are running now,
(of which last houre we have heard three quarters strike,
more then fifteen hundred of this last two thousand spent)
In all this six thousand, and in all those, which God may
be pleased to adde, *In domo patris*, In this House of his
Fathers, there was never heard quarter clock to strike,
never seen minute glasse to turne."

Milton, in his last Cambridge oration—a speech, as we
noted before, full of Baconian optimism—put what seemed
to him defeatist doctrine into the mouth of Ignorance,
who would abandon the quest of knowledge because time
was now too short to achieve lasting fame. But a gener-
ation later Sir Thomas Browne could still affirm that " 'Tis
too late to be ambitious. . . . We whose generations are
ordained in this setting part of time, are providentially
taken off from such imaginations. . . ." We may observe
that, for Donne and Milton and Browne alike, the brev-

46

ity of earthly time and fame is nothing when weighed against immortality.

These two beliefs or ideas, though they could be involved with science, were themselves hardly scientific, and they invite a reminder of some central and universal facts of life which help more than science to explain some states of the seventeenth century mind and much of its greatest writing.

The literature of ancient Judea and Greece and Rome, from Job to Juvenal, sets forth, with infinite diversity and power, man's view of the naked human situation and the sickness of civilized society; and our writers were for the most part devoutly Christian heirs of Judea and Greece and Rome and the Middle Ages. Then they had their full share of personal experience, public and private, and their full share of the pessimism always induced by the contrast between what man is and what he might be. To speak only of timeless things, there was the great fact of mutability in individual, national, and world history, which had afflicted pagan and, despite faith in Providence, Hebrew and Christian minds; the weariness and despair of many centuries were concentrated, along with a prayer for the stability of heaven, in the last and most moving stanzas of *The Faerie Queene*. There was the everpresent and personal fact of sin, with all its eternal consequences. To quote George Herbert *(The Agonie)*,

> Philosophers have measur'd mountains,
> Fathom'd the depths of seas, of states, and kings,
> Walk'd with a staffe to heav'n, and traced fountains:
> But there are two vast, spacious things,

47

The which to measure it doth more behove:
Yet few there are that sound them; Sinne and Love.

There was finally, the fact of death, even though it was attended by the trumpet notes of complete faith in immortality. The earlier seventeenth century gave birth to nearly all the greatest meditations on death in English literature —in the King James Bible, Shakespeare, Webster, Donne, Ralegh, Drummond, Bacon, Henry King, Sir Thomas Browne, Jeremy Taylor, Milton, and others. It was not science that evoked these reverberating utterances; the scientific temper would have stifled almost all of them— and did, in the latter part of the century.

One main agent in the process that cooled religion, emotion, and language brings us back to the subject of science from which we have strayed. I mean the tradition of philosophic scepticism which had flourished in antiquity and revived, with increasing scientific support, in the sixteenth and seventeenth centuries. Without trying to define its historical components and variations, one may speak, loosely, of a critical rationalism which took nothing as established and certain and which, in extreme forms, accepted flux and philosophic ignorance and uncertainty as the human condition. Sceptics might start from various positions, abstract scepticism, libertine individualism and naturalism, anti-Christian Deism. Montaigne's question, "What do I know?" was hardly a scientific question, although, as it continued to be asked, it acquired scientific props. Behind it was the growing pressure that came from challenges to authority of all kinds, in the more popular fields of religion and government as well as in science.

Science and Literature

It would no doubt be unthinkable to talk about science and seventeenth century literature without quoting those lines from Donne's *First Anniversary* (1611) which have been quoted a thousand times in the last forty years:

> And new Philosophy calls all in doubt;
> The Element of fire is quite put out;
> The Sun is lost, and th' earth, and no mans wit
> Can well direct him where to looke for it.
> And freely men confesse that this world's spent,
> When in the Planets, and the Firmament
> They seeke so many new; they see that this
> Is crumbled out againe to his Atomies.
> 'Tis all in peeces, all cohaerence gone;
> All just supply, and all Relation.

Some years later William Drummond of Hawthornden echoed Donne in a fuller picture of bewilderment over the discoveries of the new astronomy, and he concluded: "Thus, Sciences by the diverse Motiones of this Globe of the Braine of Man, are become Opiniones, nay, Errores, and leave the Imagination in a thousand Labyrinthes. What is all wee knowe compared with what wee knowe not?"

Donne's lines have often been quoted as proof of "Jacobean pessimism," although the Jacobean age was in the main—if not for some intellectuals—an optimistic recovery from Elizabethan depression. But our point here is that the lines have often been quoted as proof that Donne and his fellows were uprooted and confounded by the new science. I have kept this *locus classicus* so long in

49

reserve because it seemed desirable to recall first some of the many other reasons why the seventeenth century was, as every age is for men of imaginative intelligence, an age of anxiety. Donne felt those general pressures; also, he was writing after years of heavy personal trials. But he was not a scientific modernist in the Baconian sense; still less was he a sceptical modern intellectual lost in a meaningless universe. So far as we know, Donne never at any time in his life entertained doubts of the Christian faith. In the two *Anniversaries* his purpose was self-analysis, a spiritual stock-taking, and—like Godfrey Goodman a little later, as we observed—he pictured nature's decay and man's sinful intellectual pride, ignorance, and confusion in contrast with the one sure resource, religion; hence he freely used new science, old science, and fable, as these served his turn at the moment. So, too, William Drummond's melancholy reflections issued in an ecstatic vision of the soul returning to its heavenly home. One could not readily name any man of the seventeenth century whose religious belief was overthrown by science, as it so often was in the nineteenth—though in the latter part of the century we do find the natural theology of Deism emerging as a main current.

One kind of reaction to the rapid growth of knowledge, especially but not merely science, was so common in the earlier part of the period that we must take note of it: that is, the fear of excessive "curiosity," of knowledge outrunning wisdom and faith, of the quest of secular knowledge and power that led to the pride and the fall of Adam and Eve. For a cloud of witnesses I may refer to Howard Schultz's *Milton and Forbidden Knowledge*;

here I can mention only four (I quote laymen partly because they were poets and partly because some later bishops were buoyant Baconians). Among the most moving pictures of intellectual and moral disorder and most urgent pleas for wisdom were those of the Christian-Stoic George Chapman and the darkly Calvinistic statesman Fulke Greville. Then, as a pendant to the lines from Donne's *First Anniversary*, we may recall the long passage in the *Second*, where he catalogues examples of the ignorance that attends new scientific discoveries and speculations, here mainly concerning human physiology; and Donne ends, like Robert Burton and others, by leaving the ultimate revelation to faith and heaven.

Our last witness, Milton, had in his youth felt no qualms in celebrating the Baconian conquest of nature, but in *Paradise Lost* Eve is seduced by Satan's specious temptation of godlike knowledge and power beyond human limits. This theme, which is central in the poem—and which is partly developed in the dialogue on astronomy—is re-emphasized in the conclusion. After the penitent Adam has declared his newly and hardly won ideal of Christian faith, humility, obedience, and love, the archangel replies, in lines akin to those quoted a while ago from George Herbert:

> This having learnt, thou hast attaind the Summe
> Of wisdome; hope no higher, though all the Starrs
> Thou knewst by name, and all th' ethereal Powers,
> All secrets of the deep, all Natures works,
> Or works of God in Heav'n, Aire, Earth, or Sea. . . .

And Adam, leaving Paradise for the grim world of history, has before him the hope, not of membership in the

Royal Society, but of achieving a happier paradise within himself.

Looking about our own world, which reaches toward the angels chiefly through rockets and missiles, we can hardly say that the many seventeenth century men who set wisdom above knowledge and power were obscurantists. And that they were not attacking men of straw we realize when we consider the intellectual and moral climate of the Restoration period, the effects of the first modern scientific philosophies. We must take for granted the discoveries of science proper, such as the law of inertia, an approach to modern atomism, and the mathematical workings of gravity, which, to use Dryden's words again, revealed almost a new Nature.

On its highest level, critical rationalism was represented by the expert mathematician Descartes, whose philosophy left room for God and mind, and the would-be mathematician Hobbes, who left room for neither (at any rate in recognizable form). In England Descartes was, at least for a time, loudly applauded, while Hobbes was the great bogeyman of a whole generation of conservatives. Yet the doctrine or main drift of Descartes was hardly less destructive of traditional values, religious, ethical, and imaginative, than the thoroughgoing mechanistic materialism of Hobbes; and Descartes seems to have had even less historical and cultural sensibility than Hobbes (who began with a translation of Thucydides and ended with a verse translation of Homer). In brief, the acid of critical rationalism, sprayed over the whole field of intellect and imagination, exterminated, slowly, many tares and cockles which had long flourished in the human mind and obscured its

vision of truth; and it destroyed, in time, such poisonous weeds as belief in witchcraft. But it also ate at the roots of religious and imaginative belief, of myth and symbol, by which the age, like earlier ages, had lived. The traditional world-view could not easily be translated into the terms of mass and velocity, mechanism and atomism. God the Father and Creator became the first cause of motion, a ghostly x. Man, the lord of creation, became a superfluous accident outside the cosmic machine. The human mind was still a microcosm, but not in the old sense; it was now a miniature system of bodies in motion. The will, the moral rudder of man's ship, became the last, decisive appetite in a deterministic sequence. The great chain of being dwindled from a dynamic vision to a Deistic formula. Nature, "the Art of God," might still support the "argument from design," but the treasury of emblems and divine hieroglyphics and "signatures" became for progressive scientists a system of forces to be measured and exploited. The network of analogies and correspondences which had made all creation a living unity dissolved in the cold dry light of fact and reason. The music of the spheres was no longer audible to the spiritual ear; and the phoenix remained dead in its ashes. Even if parts of this revolution took place chiefly in the mind of Hobbes, the climate was greatly changed. We might try to imagine Donne's picture of eternity in a sermon of Tillotson's, or the conclusion of *Urn-Burial* or *The Garden of Cyrus* in Locke's *Essay concerning Human Understanding*. The Adam of Dryden's operatic version of *Paradise Lost* appeals to Hobbesian determinism.

We cannot, however, overlook the later Cambridge Pla-

tonists, Henry More and Ralph Cudworth, who, accepting the new science, strove to reinterpret and reassert traditional views and values against Descartes and Hobbes. More's account of God and space influenced Newton; his insistence on the reality of spirit, on the unity of the world, was to come to life again in Coleridge and Wordsworth, and supported Yeats when he recoiled from the "grey truth" of science. We might, too, think of such an ally of More and Cudworth as the eminent naturalist John Ray; and of a work of grandiose "scientific" imagination by a student of More and Cudworth, Thomas Burnet's *Sacred Theory of the Earth*, which might be called a kind of geological *Paradise Lost* or a sequel to both the pessimistic Godfrey Goodman and the optimistic George Hakewill, and which started a tidal wave of controversy. Then, too, though his meditations in prose and verse were not published, there was Traherne's religious response to ideas of infinity.

But these men did not set or represent the tone of Restoration literature. In the new world the soul did not experience its old visions and agonies, nor was language available to express them. There is a gulf between Donne's contrasting of the Church Universal of Scripture and the divided church of history—

Show me deare Christ, thy spouse, so bright and cleare . . .

and Dryden's earnest desire for an absolute authority:

Such an Omniscient Church we wish indeed;
'Twere worth Both Testaments, and cast in the Creed.

54

And we might add, though such parallels are quite unfair to Dryden's genius, two pictures of the resurrection:

> At the round earths imagin'd corners, blow
> Your trumpets, Angells, and arise, arise
> From death, you numberlesse infinities
> Of soules, and to your scattred bodies goe. . . .

> When ratling Bones together fly
> From the four Corners of the Skie. . . .

The new poetic temper was adumbrated by Sir William Davenant and Hobbes in their discussion of Davenant's *Gondibert* (1650). The kind of heroic poetry now acceptable was the rational depiction of "nature," of mundane actuality, freed from the supernatural fictions of traditional epic and romance. The stage was set for Restoration comedy and the political satires of Dryden and others—including Marvell, who in a more propitious age had been a uniquely complex, subtle, and sensitive metaphysical lyrist. In general, to repeat the commonest of commonplaces, Restoration literature is rational, civilized, public; it shuns "enthusiasm" and knows no mysteries.

In the civilizing process, science and scientific rationalism played both negative and positive roles. We might think of Isaac Barrow's and Newton's view of poetry as "a kind of ingenious nonsense," or of Locke's virtually similar opinion. But a more useful witness is Thomas Sprat, in his *History of the Royal Society*. Sprat did not oppose all poetry (indeed his own bad poems won him the name of "Pindaric Sprat"), and the future bishop did not re-

ject the Bible as a poetic quarry, but his great hope for poetry was in a nature purged of fable and consonant with scientific truth. This was no doubt an inevitable aim, yet it typifies the division the age was making between the old and the modern world and the death of the unified and "magical" and fundamentally religious vision which had given birth to so much great writing. At any rate, scientific discovery and thought continued on their triumphant course. Science was being so far assimilated and accommodated as to provide a new basis of intellectual security; and Newton's conceptions of the nature of light and the cosmic order came to inspire new raptures of illuminated understanding, if seldom good poetry. This sense of security may be said to be reflected in the march of the now dominant heroic couplet, in contrast with the infinite variety of earlier lyrical and private verse.

As for the technique of prose, we identify the earlier part of the century (some of whose writers survived into the newer world) with the richly figurative eloquence of Donne, Milton, Browne, and Jeremy Taylor. In that earlier period plain prose had been written in far greater abundance, in histories, pamphlets, textbooks, and many other forms, but, in general, plain diction did not make the kind of modern prose established by Dryden, disciplined syntax and symmetry as well as urbane conversational ease. There were various causes for the change, among them the anti-Ciceronian movement in which Bacon had been a leader. But it is the Baconian scientific ideal that concerns us. The bare precision of Hobbes was one early portent of the new philosophic and scientific prose. The general diffusion of the rational and scientific temper

affected all kinds of writing, even the sermon, and Jeremy Taylor's poetic flights were frowned upon by Restoration divines. One scientific bishop attacked both the Cambridge Platonists and "enthusiastic" sectaries for cloudy, figurative language, and wished for "an Act of Parliament to abridge Preachers the use of fulsom and lushious Metaphors." In science the spearhead of the movement was the Royal Society. The one famous passage in Sprat's *History* is his proclamation of the ideal of exact, denotative language as the necessary medium of scientific knowledge and thought.

However necessary that was, the general climate, as we have seen, affected nonscientific prose, and it could not but affect poetry too. Whereas Shakespeare and his fellows had thought in metaphors, the most complexly expressive mode of thought and feeling, the main texture of Restoration verse was prose statement, more explicit and denotative than figurative. At the same time, science as well as neoclassical theory contributed to a kind of abstractionism which had begun to appear long before, that is, a partial shift from concrete particulars to generalized concepts, the phrases that go under the name of Augustan "poetic diction."

The literally epoch-making changes in outlook and expression that have been sketchily summarized belonged no doubt to the inevitable process of growing up, the making of the modern mind. Happily the process remains incomplete, since the poetic vision has not yet been killed by the spirit of positivism, though many modern poets have been consciously oppressed by the withering of "myth" in a scientific and technological civilization. Look-

ing back at the seventeenth century, we can hardly deny
that for literature progress entailed far greater losses than
gains, that one large effect of science was to circumscribe,
blunt, and impoverish the rich, all-embracing sensibility and
expressive power that had flourished in the earlier period.
The writers of poetry and prose whom we chiefly read and
reread are the great race who lived before or outside the
Enlightenment.

Select Bibliography

Anyone who discusses this topic must acknowledge large debts to the literary scholars and scientists who have in recent decades made a new world of ideas accessible. A number of them and their writings are listed here.

Allen, Don Cameron. *The Star-Crossed Renaissance: The Quarrel about Astrology and Its Influence in England.* Durham, North Carolina, 1941.

Anderson, F. H. *The Philosophy of Francis Bacon.* Chicago, 1948.

Babb, Lawrence. *The Elizabethan Malady: A Study of Melancholia in English Literature from 1580 to 1642.* East Lansing, 1951.

Baker, Herschel. *The Wars of Truth: Studies in the Decay of Christian Humanism in the Earlier Seventeenth Century.* Cambridge, Massachusetts, 1952.

Boas, Marie. "The Establishment of the Mechanical Philosophy." *Osiris,* x (1952), 412-541.

—————. *Robert Boyle and Seventeenth-Century Chemistry.* Cambridge, 1958.

Burtt, Edwin A. *The Metaphysical Foundations of Modern Physical Science.* New York, 1925; revised 1932; reprinted 1954.

Bush, Douglas. "Science and Scientific Thought." Chap. ix, *English Literature in the Earlier Seventeenth Century 1600-1660.* Oxford, 1945.

—————. *Science and English Poetry: A Historical Sketch, 1590-1950.* New York, 1950.

Butterfield, Herbert. *The Origins of Modern Science, 1300-1800.* London, 1949; 2nd edition, 1957.

Chalmers, Gordon K. "Sir Thomas Browne, True Scientist." *Osiris,* ii (1936), 28-79.

Coffin, Charles M. *John Donne and the New Philosophy.* New York, 1937; reprinted 1958.

Collingwood, R. G. *The Idea of Nature.* Oxford, 1945.

Douglas Bush

Craig, Hardin. *The Enchanted Glass: The Elizabethan Mind in Literature.* New York, 1936.

Crombie, A. C. *Medieval and Early Modern Science.* 2 vols., New York, 1959. Revised edition of *Augustine to Galileo: The History of Science A.D. 400-1650.* London, 1952.

Ducasse, C. J. "Francis Bacon's Philosophy of Science." In *Structure, Method, and Meaning,* ed. P. Henle et al. (New York, 1951), and *Theories of Scientific Method,* ed. E. H. Madden (Seattle, 1960).

Duncan, Edgar H. "Donne's Alchemical Figures." *ELH: A Journal of English Literary History,* IX (1942), 257-85.

Dunn, William P. *Sir Thomas Browne: A Study in Religious Philosophy.* Minneapolis, 1950.

Hall, A. R. *The Scientific Revolution 1500-1800: The Formation of the Modern Scientific Attitude.* London, 1954; reprinted, Boston, 1956.

Harris, Victor. *All Coherence Gone.* Chicago, 1949.

Hartley, Sir Harold, ed. *The Royal Society: Its Origins and Founders.* London, 1960.

Hinman, Robert B. *Abraham Cowley's World of Order.* Cambridge, Massachusetts, 1960.

Huntley, Frank L. "Sir Thomas Browne: The Relationship of *Urn Burial* and *The Garden of Cyrus.*" *Studies in Philology,* LIII (1956), 204-19.

Johnson, Francis R. *Astronomical Thought in Renaissance England: A Study of the English Scientific Writings from 1500 to 1645.* Baltimore, 1937.

Jones, Richard F. *Ancients and Moderns: A Study of the Background of the Battle of the Books.* St. Louis, 1936.

Jones, Richard Foster and Others Writing in His Honor, *The Seventeenth Century: Studies in the History of English Thought and Literature from Bacon to Pope.* Stanford, 1951.

Kocher, Paul H. *Science and Religion in Elizabethan England.* San Marino, 1953.

Kuhn, Thomas S. *The Copernican Revolution: Planetary*

Astronomy in the Development of Western Thought. Cambridge, Massachusetts, 1957; reprinted, New York, 1959.

Laird, John. *Hobbes.* London, 1934.

Lovejoy, Arthur O. *The Great Chain of Being: a Study of the History of an Idea.* Cambridge, Massachusetts, 1936; reprinted, New York, 1960.

Mazzeo, Joseph A. "Notes on Donne's Alchemical Imagery." *Isis*, XLVIII (1957), 103-23.

Merton, Egon S. *Science and Imagination in Sir Thomas Browne.* New York, 1949.

Murray, W. A. "Donne and Paracelsus: An Essay in Interpretation." *Review of English Studies*, XXV (1949), 115-23.

Nicolson, Marjorie H. *The Breaking of the Circle: Studies in the Effect of the "New Science" upon Seventeenth Century Poetry.* Evanston, 1950; revised edition, New York, 1960.

——————. *Mountain Gloom and Mountain Glory: The Development of the Aesthetics of the Infinite.* Ithaca, 1959.

——————. *Science and Imagination.* Ithaca, 1956.

——————. *Voyages to the Moon.* New York, 1948.

Read, John. *Prelude to Chemistry: An Outline of Alchemy.* London, 1936; New York, 1937.

Schultz, Howard. *Milton and Forbidden Knowledge.* New York, 1955.

Svendsen, Kester. *Milton and Science.* Cambridge, Massachusetts, 1956.

Taylor, F. Sherwood. *The Alchemists: Founders of Modern Chemistry.* New York, 1949.

Thorndike, Lynn. *A History of Magic and Experimental Science, Volumes VII-VIII, The Seventeenth Century.* New York, 1958.

Tillyard, E. M. W. *The Elizabethan World Picture.* London, 1943.

Tuveson, Ernest L. *Millennium and Utopia: A Study in the Background of the Idea of Progress.* Berkeley, 1949.

Westfall, Richard S. *Science and Religion in Seventeenth-Century England*. New Haven, 1958.

Whitehead, Alfred N. *Science and the Modern World*. New York, 1925.

Willey, Basil. *The Seventeenth Century Background: Studies in the Thought of the Age in Relation to Poetry and Religion*. London, 1934; reprinted, New York, 1953.

Wolf, A. *A History of Science, Technology, and Philosophy in the 16th & 17th Centuries*. London and New York, 1935; revised by D. McKie, 1950; reprinted, New York, 1959.

Science and Visual Art*

JAMES S. ACKERMAN

A SEVENTEENTH CENTURY audience would have thought it quite proper that Professor Bush's intriguing analysis of poetry should be followed by a discussion of painting and sculpture; Horace's phrase *ut pictura poesis*—as is painting, so is poetry—was a commonplace in that period, when the rise of academies made the theory of art as well as of literature far more important than it had been before.[1] That the theorists should have represented painting as mute poetry is due partly to the fact that in searching among ancient authors for a philosophic foundation, they could find it only in treatises on poetics, such as those of Aristotle and Horace, and in the vast literature on rhetoric—no Greek or Roman texts on painting survived. But painting often was alluded to in the literary sources as a parallel to poetry. Aristotle, for example, compared the plot of a drama to the drawing for a picture. His Roman

JAMES S. ACKERMAN is Professor of Fine Arts at Harvard University. He is former editor of *The Art Bulletin*, and the author of *The Cortile del Belvedere* and *The Architecture of Michelangelo*.

*I am greatly indebted for stimulus and factual support to members of a seminar on this theme, held in 1959 at the University of California, Berkeley, and in particular to Mr. Robert Beetem, Mr. Timothy Kitao, and Mr. Richard Overstreet.
Photographic sources: Figs. 1, 5, 7, and 9 appear by gracious permission of H. M. the Queen; Fig. 3, Gallerie e Musei Vaticani; Figs. 4, 6, and 8, Fratelli Alinari.

[1] See R. Lee, "Ut Pictura Poesis: the Humanistic Theory of Painting," *The Art Bulletin*, XXII (1940), 197ff

successors extended the simile to matters of content, and encouraged Renaissance critics to demand that painting, like drama, be concerned with noble and elevated themes calculated to instruct as well as to please; themes whose chief purpose was to portray and to communicate the varied actions and passions of human beings.

This curious marriage of the visible and the verbal encouraged one of the favorite intellectual pastimes of the Renaissance—the *Paragone*, or comparison of the arts, in which ingenious arguments would be adduced to prove the superiority of one over another. Leonardo da Vinci's well-known *Paragone*, written before the tyrannical age of academic criticism, classified the effects that could and could not be produced by poets and by painters, and decided in favor of the latter on the grounds that painting is associated with natural rather than moral philosophy; or, as we should say today, with science rather than ethics.[2]

If poetry and painting really were two means to the same end, and if Leonardo's argument remained valid, then we might expect to find that the new science of the seventeenth century influenced artists as much as, or even more than, poets. There should have been a school of metaphysical painters whose canvases were visual counterparts of the cosmological metaphors of Donne and Browne. There was no such school. The written image proved to be sensitive to the kind of natural phenomena newly revealed by science, while the painted image was not.

One reason for this was that in the century that sep-

[2] Leonardo da Vinci, *Treatise on Painting* (codex Urb. Lat., 1270), in McMahon ed., Princeton, 1956, I, 3-44

arated Leonardo from Galileo, the range of human knowledge extended beyond the range of vision. Leonardo could still be the *uomo universale* because for him knowledge gained through the naked eye was at once the raw material of art and of science. Renaissance science, even when concerned with phenomena too distant or too small to be seen, conformed to common sense experience, and it was just for this reason that an artist like Leonardo, trained from childhood in observation, could be a more original scientist than the physicists and anatomists of his time, who looked rather at ancient books than at the world around them.

But the great hypotheses of Copernicus and Galileo explained celestial and terrestrial motion in ways that contradicted common sense experience, and there was no immediate way in which they could affect the painter's representation of objects. Poets, however, were not confined to the visible—like scientists, they expressed themselves in the less concrete form of words, and might respond to any scientific postulate that could be related to human actions and passions, regardless of whether they could verify it by observation, or even properly understand it. Furthermore, since science and literature shared a common language, it was possible for literary style as well as content to be influenced by scientific prose.

So it happened that artists of the seventeenth century were in some ways farther removed from scientific discovery than their predecessors. The medieval image of the cosmos, for example, was actually better suited to visual representation than to words; it was itself a work of art. St. Isidor of Seville, writing *On the Nature of Things*,

65

started each chapter with a symbolic image, and then proceeded to explain what it signified. Even those sciences that were of immediate practical significance to artists got beyond their reach after 1600.

The universal method of perspective invented by the geometer Desargues in 1636 was so abstruse that artists could not understand it, even after it had been "translated" into studio language by Bosse.[3] They followed the rules formalized by the Italian ceiling painter Fra Pozzo in 1693, which do not contain a single proposition requiring mathematics more advanced than that used in the fifteenth and sixteenth centuries.[4] Similarly, while mathematicians became acquainted with conic sections and the construction of the ellipse in the sixteenth century, and Serlio and Dürer knew of them, architects throughout the seventeenth century continued to construct ovals by combining the arcs of circles, as in the Square of St. Peter's.

Anatomy was the basic course in all the new academies of art, but painters and sculptors, who were interested only in the bones and muscles, had no need to penetrate farther into the subject than Leonardo, or at most, Vesalius, had done. Harvey's discovery of the circulation of the blood could not affect the way they drew a figure. Shortly after 1600, Agostino Carracci, one of the family who founded the Bolognese Academy, and whose painting gave a dynamic impetus to the formation of the Baroque style, wrote the following: "While it is useful for the painter to devote time to anatomy—the general nature of which

[3] A. Bosse, *Manière universelle de M. Desargues pour pratiquer la perspective* . . . , Paris, 1647
[4] *Perspectiva Pictorum et Architectorum Andreae Putei*, Rome, 1693

66

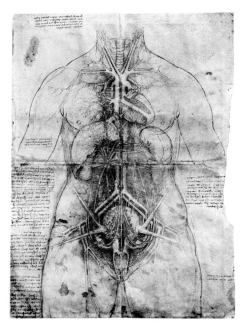

1. Leonardo da Vinci, Anatomical study,
Windsor Castle

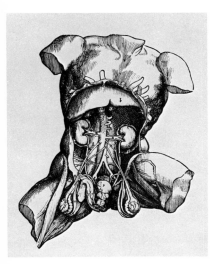

2. Figure from A. Vesalius, *De
Humani Corporis Fabrica*, II

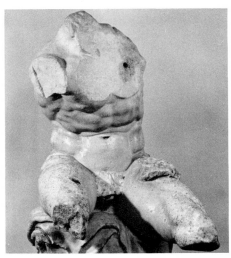

3. The "Belvedere Torso," Vatican

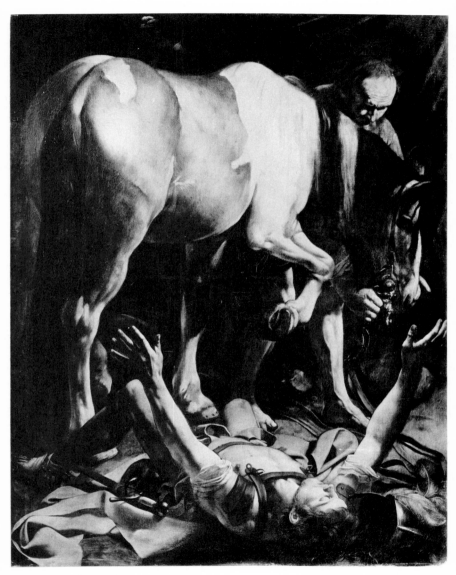

4. Michelangelo da Caravaggio, *The Conversion of St. Paul*, Rome, Santa Maria
del Popolo (photo: Alinari)

5. Agostino Carracci, drawing, Windsor Castle

6. Giorgio Vasari, *Perseus and Andromeda*, Florence, Palazzo Vecchio

7. Annibale Carracci, drawing, Windsor Castle

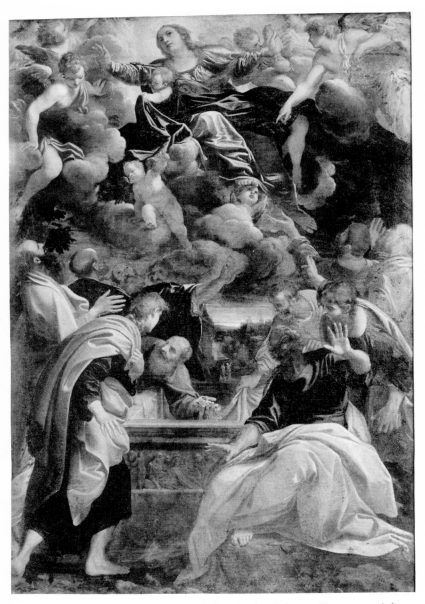

8. Annibale Carracci, *Assumption of the Virgin*, *Bologna*, Pinacoteca (photo: Alinari)

9. Annibale Carracci, drawing, Windsor
Castle

10. Nicolas Poussin, drawing, London,
Oppé Coll.

it is good to know—it is not, however, necessary to hunt around inside, the way doctors do."[5]

Indeed, the *De Fabrica*, which Vesalius began in Padua in 1537, was a unique monument in the history of our civilization, representing a brief moment in which art and science were perfectly fused. The text, like St. Isidor's, was dependent on the illustrations, but the illustrations revealed with striking clarity and precision the results of dissections (text Fig. 2). The artist was no mere hireling; it was he who brought the corpses to life and the text as well, so that the *Fabric* described by the anatomist came to have meaning and application to laymen and artists as well as to scientists.[6] The book would have been impossible without the support of Leonardo's graphic innovations, which first demonstrated the power of the image over the word in anatomical studies (Fig. 1), and Leonardo in turn depended on the major contributions of fifteenth century art—rationalized proportion, perspective, the illusion of relief and of light.[7] Moreover, Vesalius' engraver applied the method of Leonardo to figures whose poses and proportions he borrowed from the most vital artists of his own time, particularly Raphael and Michelangelo, and from the antique sculpture that was being so

[5] In H. von Bodmer, "Le note marginali di Agostino Carracci nell' edizione del Vasari del 1568," *Il Vasari*, X (1939), 3-4, 99

[6] For the plates, see J. Saunders and C. O'Malley, *The Illustrations from the Works of Andreas Vesalius of Brussels*, Cleveland-New York, 1950; and for commentary on the art-historical significance, W. M. Ivins, in *Three Vesalian Essays* (New York Academy of Medicine, History of Medicine Series, No. 11), New York, 1952, pp. 45-128

[7] E. Panofsky, "Artist, Scientist, Genius: Notes on the 'Renaissance-Dämmerung,'" *The Renaissance. A Symposium, The Metropolitan Museum of Art, February 8-10, 1952*, New York, pp. 77ff

avidly collected in the early sixteenth century (compare Figs. 2 and 3). That the engraver should have relied on antique as well as modern images of the body is quite consistent with the approach of his employer. The ancients were still believed to be the true source of knowledge, and Vesalius was sufficiently respectful of his Roman precursor Galen to apologize when his dissections forced him into disagreement.

We know little of the presumed engraver Stephan von Calcar, but judging from his style he must have been a northerner who studied in Rome in the 1530's, and probably was in Venice while the book was being prepared. This is relevant to my point, because it rarely happened again that the contribution of art to scientific illustration was individualized enough to suggest anything of the biography of the illustrator. Never again was art so essential to science, nor science to art; later anatomical illustrations echoed the schemes of Leonardo and Vesalius with minor concessions to changes in style and taste, until, in recent times, they froze into formulas of distasteful crudity.

In short, art was as little use to scientists in the seventeenth century as scientific discovery was to the artists. Examples of scientific subject-matter in painting do occur but the science usually is not up-to-date. Our glimpse at Vesalius calls to mind one of the great pictures of the seventeenth century, Rembrandt's record of the anatomy performed by Dr. Tulp in Amsterdam in 1632. While this is a work of astonishing artistic power and inventiveness, it is anything but a record of scientific progress. A recent study by William Heckscher shows us that ceremonial public anatomies of this kind were a survival from

the Middle Ages; their purpose was at once didactic and moralizing.[8] Probably the event stimulated far more progress in Rembrandt's field than it did in Dr. Tulp's.

Portraits of scientists such as this one did provide painters with occasional opportunities to refer to modern discoveries. Public interest in astronomy and geography may have played a part in popularizing a new theme in early seventeenth century art, the paired portraits of the Greek philosopher-scientists Democritus and Heraclitus, who appear in an example by Terbruggen with globes representing heaven and the earth.[9] The construction of such globes by the gore-system and by Mercator projections was a new discovery in the sixteenth century, but the context in which they appear here is certainly not calculated to attract attention to scientific progress. The theme brings us again to the marriage of art and poetry because it is actually a pretext for the portrayal of human passions. In this and in other versions of the double "portrait," one philosopher is made melancholy by his contemplation of the earth, the other is made a buffoon by his study of the heavens; it is an image not of science but of human frailty.

Of the many examples of this theme in seventeenth century art, I chose Terbruggen's because of its distinctive style. A moment ago I referred to the influential new art of the Carracci brothers, which can be described as an idealization of man and nature based on close observation. Another contemporary—and equally influential—current

[8] W. S. Heckscher, *Rembrandt's Anatomy of Dr. Nicolaas Tulp*, New York, 1958

[9] W. Weisbach, "Der sogenannte Geograph von Velasquez und die Darstellungen des Demokrit und Heraklit," *Jahrb. d. preuss. Kunstsamml.*, XLIX (1928), 141-158

James S. Ackerman

represented by Terbruggen's philosophers had its source in the painting of Michelangelo da Caravaggio, which is also based on close observation, but which harshly rejected the principle of idealization or ennoblement that was one of the connecting links between poetry and painting (Fig. 4). These painters sought out the ruffians and bald-pates as a means of stating their independence from the artificialities of the late Renaissance.

I am speaking of artificialities which characterize the dying years of the art we call Mannerist—a style formed in central Italy by the generation succeeding Raphael's and Michelangelo's in the 1520's and 30's.[10] Like their contemporaries Copernicus and Luther, the early Mannerists upset the harmony and stability of the Renaissance image of man; they distorted bodily proportion, created ambiguous space, and expressed in movement and composition the disturbed and unstable psychology of their times. Mannerism was a vigorous declaration of independence from the classic Roman style of the first decades of the century; but like the surrealist art of our time, it was a declaration that contained no potential for development. By mid-century its forms had become fixed in arid and affected formulas serving an overly complicated allegorical subject matter (Fig. 6). Social changes also helped to institutionalize the arts. While the Council of Trent was attempting to tabulate what was and was not proper in religious art, the artists themselves formed societies called academies, which made aesthetic constitutions and imposed them on

[10] W. Friedlaender, *Mannerism and Anti-Mannerism in Italian Painting*, New York, 1957

70

young students.[11] A major purpose of the academies was to give artists the status of poets and philosophers, to raise their calling from the level of a mechanical to that of a liberal art, and to move education out of the studio into a pseudo-university. This amounted to an admission of the superiority of the word over the image; only fifty years after Leonardo had proclaimed the inferiority of poetry to painting, social aspiration had encouraged painters to sacrifice their position; and as they aimed to become intellectuals rather than observers, their art lost contact with life. As intellectuals they eagerly engaged in theory and criticism, for it is a habit of our culture to write the most about art in those periods when it is least worth looking at. From the 1530's on, books of instruction, theory, and biography appeared in a steady and swelling stream. Since their purpose was to give the arts a philosophical foundation, they avoided the kind of utilitarian observations found in Leonardo's treatise; in fact they were not at all concerned with vision and illusion, but substituted for Leonardo's Aristotelian empiricism a Neo-Platonic idealism that encouraged their abandonment of the everyday world.[12] This world was held to be a crass reflection of a higher reality: it was the artist's responsibility to represent, not things as he saw them but the *Idea* of things —that perfect principle which God had in mind at the moment of Creation. Accordingly, the way to this *Idea* was

[11] N. Pevsner, *Academies of Art, Past and Present*, Cambridge-New York, 1940, Chapters I-IV

[12] E. Panofsky, *Idea, ein Beitrag zur Begriffsgeschichte der älteren Kunsttheorie*, Leipzig, 1924 (2nd ed., Berlin, 1960); A. Blunt, *Artistic Theory in Italy, 1400-1600*, Oxford, 1940; J. von Schlosser, *La Letteratura Artistica*, 2nd Italian ed., Florence, 1956

not through observation, which would reveal only its imperfect realization in gross matter, but through celestial inspiration. The artist at his canvas thus became the earthly counterpart of the Divine Creator, who would show us not what *is* but what ought to be. Federigo Zuccaro, the President of the Roman Academy, summarized the view in an elegant bit of etymological sophistry when he traced the origin of the word *disegno* (drawing or composition) to the phrase *segno di Dì in noi* (a spark of divinity in us). Needless to say, this philosophy was also calculated to elevate the status of the artist.

The student was not, however, allowed to rely on inspiration alone; the *Idea* could be found in art if not in nature, and he was encouraged to study and to copy ancient sculpture and the painting of the masters of the High Renaissance (not however, Titian and the Venetians, whose rich colors partook of the imperfections of the sensuous world). He also was required to be extremely learned, so that he might treat the lofty themes of religion, history, and legend with what was called *Decorum*, meaning accuracy and propriety. Finally, the painter, like the courtier, had to be a master of grace and facility, so that speed of execution was held a virtue. No wonder that in a generation not blessed with many geniuses, this mystical system encouraged the most uningratiating kind of academism.

Academism characterized much of the scientific work of this period, too. The average scientist, like the artist, found his ideal in antiquity, and was unwilling to accept what he saw if it conflicted with ancient texts. Even the great Kepler was a Mannerist of sorts—he used his knowledge of the cosmos to construct horoscopes for his em-

ployers; he retained ancient animistic beliefs, representing the sun as the soul of the universe, and the earth as a breathing organism, and his Neo-Platonic proclivities emerged in his first major work of 1596, in which he attempted to inscribe the spheres of the planets within the five regular geometrical solids, and attributed the hypothesis to divine inspiration.

The Mannerist rejection of life and nature brought Renaissance art to a crisis that could be resolved, as the Carracci and Caravaggio realized, only by accepting the outer rather than the inner world as the primary source of inspiration. Around 1590, when a small number of painters in Northern and Central Italy were formulating this fresh approach to reality, Galileo began to teach at Padua, Kepler began to publish, and Galileo's father joined a new musical society opposed to what might be called the Mannerist intricacies of the madrigalists and committed to restoring dramatic intensity to vocal music through monodic composition. Apparently the arts were joining the sciences in the systematic investigation of natural phenomena that Francis Bacon so nobly fashioned into the credo of the laboratory worker.

But before we become enmeshed in one of those superficial historical generalizations that Professor Toulmin warned us to avoid, let us ask whether there is a meaningful relationship between naturalism in the arts and scientific inquiry; and further, whether we are justified in calling the artists of this period naturalists.

First, we must admit that the aim of the naturalist in painting is to show us the way things *seem*—to give us a convincing illusion—and that nothing could be farther

removed from the purposes of the empirical scientist, who aims to penetrate beyond appearances to their causes. Indeed, the cornerstone of Descartes' scientific method was a profound suspicion of sense impressions. Furthermore, the image of sixteenth and seventeenth century scientists as purely empirical investigators is quite inaccurate. Many of the great scientific advances of this age were theoretical in nature and not basically dependent upon new observations; witness the curious fact that the Copernican hypothesis of a heliocentric system was based largely on imprecise ancient observations, while this literally earth-shaking innovation was rejected by the Danish astronomer Tycho Brahe, the most competent and systematic observer of his time.

Similarly, it is only by contrast to the affectations of Mannerism that Caravaggio may be called a naturalist.[13] His compositions reveal an interest in superficial peculiarities of feature and body; and yet the limbs of his figures are often no more accurately joined than in Mannerist pictures, nor is the murky setting more clearly specified (Fig. 4). The violent, channeled light that dramatizes his figures is a triumph of the imagination, not the record of observation. It could be produced only by the artifices of modern stagecraft. Girolamo Mancini, one of the few seventeenth century critics who forgave Caravaggio his departure from idealization, wrote: "It is characteristic of this school to illuminate with a unified light coming from above without reflections . . . so that they manage by making the lights very light and darks very dark to give relief to the pictures, *but in a non-natural manner*, never

[13] W. Friedlaender, *Caravaggio Studies*, Princeton, 1955

done nor thought of by previous centuries or older painters."[14]

Neither the scientists nor the painters of the early seventeenth century were as single-minded in their empirical method as Leonardo and many of his precursors had been. We cannot even claim that where Caravaggio was most faithful to his models he was more of a naturalist than an early fifteenth century painter like Pisanello, whose fascinating sketches of animals and birds would be of more use to a zoologist than any master drawing of the seventeenth century. The naturalism of such late Gothic sketchbooks was not prompted by scientific experiment, nor were other great moments of naturalism—late Hellenistic sculpture, for example, or the painting of Courbet and Eakins in the last century.

Around Caravaggio's work there raged a tempest in criticism as violent as those of the nineteenth century.[15] He was uncommonly popular with high-ranking amateurs, but conservative churchmen often rejected his religious pieces or removed them once they were hung. Critical opposition came mostly from the Carracci circle; a Mannerist theorist such as Federigo Zucarro brushed off Caravaggio's first major ecclesiastical commission with the comment, "What's all the noise about? I see nothing here but Giorgione's concept." Zuccaro evidently thought that the work typified the sensuous, and therefore inferior, color and light of Venetian painting, and was somewhat

[14] G. Mancini, *Considerazioni sulla pittura* (*ca.* 1620), ed. Marucci and Salerno, Rome, 1957, I, 108

[15] M. Cutter, "Caravaggio in the Seventeenth Century," *Marsyas*, New York, 1941, I, 89-115

old-fashioned.[16] It was Caravaggio's failure to *improve* the nature he observed that aroused opposition; his supporters came to his defense by praising his fantasy and invention more than his reproduction of reality.

The Idealist opposition to Caravaggio represented a critical attitude that ultimately dominated Baroque theory. It was best expressed by Giovanni Pietro Bellori in his *Lives of the Painters* in 1672, where Caravaggio is introduced in these words: "It is said that Demetrios the ancient sculptor was so interested in likeness that he was intrigued more by the imitation than by the beauty of things. The same we have seen in Michelangelo Merisi (da Caravaggio) who recognized no other master than the model, and without the selection of the better natural forms: It is stupendous to say, but it seems that he emulated art without art."[17]

Caravaggio's habit of painting directly from the model, and thereby favoring individual rather than general characteristics of man, threatened to reduce painting once more to a mechanical art. Francesco Albani, a pupil of Annibale Carracci, complained of Caravaggio's followers: "One sees imitations which resemble life, yet are not true; one finds no representation of character nor liveliness of movement; and since the painter like the poet should first form a concept, they now are corrupting [our art], forming no concepts [beforehand] and [finding] none in what they observe . . . they dispense with perspective, with concepts, with expression and what I should have mentioned

[16] D. Mahon, *Studies in Seicento Art and Theory*, London, 1947, p. 177

[17] G. P. Bellori, *Vite de' pittori, scultori, et architetti*, Rome, 1672, p. 201

before, with inventions."[18] Albani has no quarrel with the imitation of nature: in fact, he infers that the Caravaggisti are not natural enough in their perspective and expression. But he wants the figure to be ennobled by a concept of beauty which is comparable to that of the poets.

The new critics inherited from Mannerism the theory that the imperfections of nature must be improved by an ideal concept of form, but they believed that the ideal might be discovered by observation rather than by intro-spection or inspiration. We can trace this shift of position to its source in the circle of Annibale and Agostino Car-racci, who, like Caravaggio, left North Italy for Rome at the close of the sixteenth century. It was the coexistence of the two styles in the capital of European art that stirred up the critical controversy.

The Carracci were as keen observers of life as Caravag-gio, and spoke of the outer world as their chief source of inspiration. Agostino Carracci attacked the prince of Mannerist theorists in these words: "Vasari doesn't re-alize that the great masters of antiquity dug up their things from life and thinks that a good artist can be made from second-hand antiques rather than from the first and fore-most objects, which are alive and which one must always imitate."[19] Sketches from the Carracci studio and paint-ings of everyday subject matter prove that while their style differs from that of Caravaggio, particularly in the use of light and color, they were equally devoted to ob-servation and, indeed, were often more successful in achiev-

[18] C. Malvasia, *Felsina pittrice*, Bologna, 1678, II, 244; see also II, 258, 268f
[19] H. Bodmer, *op.cit.*, pp. 109f

ing the illusion of reality (Fig. 7). But unlike Caravaggio, the Carracci believed that unadulterated imitation was not suitable to religious, mythical, and historical subject matter: traditional themes required idealization (Fig. 8). To this extent they accepted the doctrine *ut pictura poesis*.

It seems curious that the Carracci, who demanded the ennoblement of humankind, should have been the inventors of modern caricature, through which we are most effectively degraded (Fig. 5). Even the term was coined by them: *caricare* means to weight or to load, and in this context it infers that added weight is given to distinctive characteristics of physiognomy. Actually, caricature was a logical compliment—by antithesis—to idealization, as we discover in reading the preface to a collection of etchings after Carracci genre sketches published in 1646. The editor explains that the caricaturist "follows Raphael and other fine painters who, not satisfied with natural beauty, collect [what is beautiful] from many sources, or from the most perfect statues; wherefore caricature depends on nothing but an excellent knowledge of nature's intentions in making a fat nose or a large mouth, in order to create a beautiful deformity in that object. But, since nature could not manage to distort that nose or mouth to the degree required by the beauty of the deformity, the worthy artist, knowing how to aid nature, will represent the alteration much more expressively, and will weight his portrait to the degree most suitable to the perfect deformity."[20]

I suspect that the writer's physiognomy may have been handsomely deformed by the presence of his tongue in

[20] D. Mahon, *op.cit.*, pp. 258-275, esp. pp. 261f and n.47; C. Malvasia, *op.cit.*, I, 379ff

his cheek, but still he gives us a vivid image of the artist's mission to reformulate an imperfect world.

The Carracci took idealization for granted, and were far more concerned with a new rapport with nature, but the *litterati* who sought to explain their achievement had to invent a philosophical argument that would relate idealization with observation and pry it loose from the mysticism of the Mannerists. So they proposed that the Ideal might be deduced from nature by the selection of what was good and the rejection of what was bad, and by a search for the permanent and universal essence rather than the momentary and particular.[21] Bellori justly claimed that human passions could be portrayed only by assimilating and selecting from many observations of fleeting expressions; a model could not be expected to express terror or lust for extended periods. For this reason neither the introspection of the Mannerists nor Caravaggio's studies from the model could meet the challenge of a dramatic and elevated theme.

At this point of departure from naturalism, we unexpectedly encounter a bond with science in the person of Galileo himself, who was a learned and original critic of the arts, particularly of literature, and a poet in his own right. His aesthetic principles are, in fact, remarkably close to those of his friend Monsignor Agucci, the father of Idealist art theory and the first publicist of the Carracci. In a delightful and profound study of Galileo's criticism, Erwin Panofsky recently has analyzed his preference for art of a universal and ennobling character, beginning with

[21] G. P. Bellori, "Idea," the Introduction to his *Vite*; translated in E. Holt, *A Documentary History of Art*, New York, 1958, II, 94-106

79

James S. Ackerman

a *Paragone* of painting and sculpture in which Galileo writes: "Sculptors always copy and painters do not. The former imitate things as they are, the latter as they appear; but since things are only of one kind and appear to be of infinite kinds, the painter's difficulty in attaining excellence in his art is immensely increased."[22]

While this argument favors painting chiefly because its illusions are more difficult to produce, it implies a devaluation of "copying," or naturalism, that emerges more clearly in Galileo's brief *Paragone* of painting and poetry: "In painting," he writes, "we have drawing and color, which properly correspond in poetry to phrasing and locution; which two parts, *when they are joined with decorum*, render imitation and representation perfect: they are the soul and essential form of these two arts, and we call that painter or poet most excellent who by these two means puts his figures before our eyes in the most lively fashion."[23] For Galileo, as for the Carracci, the perfect imitation is governed by decorum, by which he means "that the poses and disposition of the figures be not contrary to the requirements of the story." Accordingly, he joined Aretino in criticizing the nudity in Michelangelo's *Last Judgment*; not out of prudery, but because it was unbecoming to the saintly company.[24] In allying painting to poetry, Galileo, like the Carracci, looked for the reconciliation of sense experience and idealization. Comparing Ariosto to Tasso, he exalted the classic style of the former as "magnificent, rich and wondrous" and denigrated the

[22] E. Panofsky, *Galileo as a Critic of the Arts*, The Hague, 1954, pp. 34, 37, from Galilei, *Le opere*, ed. nazionale, Florence, 1890-1909, XI, 340-343

[23] *Ibid.*, IX, 76 [24] *Ibid.*, IX, 94

affectations of the latter, whose *Gerusalemme liberata* he compared with the brittle and complicated mannerism of Parmigianino's painting and Bandinelli's sculpture.[25] In brief, he felt that while deception is the province of art, it must be directed toward some ennobling end, and be stated in a clear and decorous style.

His critical opinions cannot be isolated from his scientific activity. By contrast to Leonardo, who found the bond between art and science in empirical observation, Galileo, like the Carracci, sought to state universal principles based on observation. Though he discovered the satellites of Jupiter and wrote on sunspots, Galileo's fame is due rather to his general laws of celestial and terrestrial mechanics. His commitment to ideal form may have been, as Panofsky suggested, the reason for his inability to accept Kepler's discovery that the planetary orbits were elliptical and that the sun was not precisely at the center of our system. He held to the theory that the planets move in circles about the sun, in conformity to the ancient and Renaissance principle that circles and circular motion were perfect, and ellipses "irregular."

As a prose stylist, Galileo represents the same clarity and refinement of expression as the Carracci. Leonardo Olschki has shown that the classic style of Ariosto's poetry was a major influence on Galileo's prose, just as the painting of Ariosto's contemporary Raphael guided the formation of the Bolognese painters.[26] It cannot be coincidence that the only literary reference I have found in the

[25] *Ibid.*, IX, 69; Panofsky, *Galileo*, p. 19
[26] L. Olschki, *Galilei und seine Zeit* (Geschichte der neusprachlichen wissenschaftlichen Literatur, III), Halle, 1927, pp. 167-197

81

James S. Ackerman

correspondence of Descartes was also to Ariosto's poetry.[27] So the language of science, which later was to influence poetic expression, apparently was inspired first by the Italian Renaissance epic. When speaking of style, we may parody Horace: "As is *science*, so is poetry."

In saying that Galileo, like some contemporary artists, made universal statements based on observation, I do not mean that the two kinds of statement are equivalent. We value the scientist's because it successfully explains the phenomena revealed by observation, and the artist's simply because it moves us, whether or not it corresponds to what we observe. So new discoveries may destroy a scientific statement but not an artistic one. In other words, while the former is susceptible to experimental proof, the latter is not.

This distinction reveals a fundamental philosophical flaw in Idealist art theory where, essentially, a hypothesis of perfect beauty was assumed to be susceptible to proof. If we accept the proposition that beauty is not to be found expressly in what we see, but must be selected and generalized from observation, how are we to know what to select and what to reject, and how may we be sure that different artists will find the same ideal? The theory actually required the addition of a standard by which perfection could be discovered by the artist and judged by the critic, and this standard was not really in nature, but in art: in ancient sculpture and in the classic Renaissance style of Raphael and his contemporaries. While the theorists did not deny their attachment to the traditional classic

[27] *Correspondance*, ed. C. Adam and G. Milhaud, Paris, 1941, III, p. 1, no. 167; letter of July 27, 1638 to Fermat

82

art, they failed to realize that by accepting it as a standard they undermined the logic of their argument. For if the process of selection must be directed by traditional forms, these forms would have to be in the artist's mind before he begins to observe; so ideal beauty would not be the *result* of selection and generalization, as was claimed, but its *cause*. It is curious that this theory was being formulated just at the time when René Descartes was analyzing the nature of perception in a way that clearly demonstrated its weakness.

How the great idealist artists did manage both to observe and to generalize we can see in their work, and the process proves to be quite different from what the critics tell us. The Carracci, Poussin, and Bernini regarded the work of art as a mean between two poles. One pole was the classic art of antiquity and the Renaissance, which they avidly sketched and studied, particularly in their youth, until the forms were engraved on their memory (Fig. 9). The other pole was life and nature, from which they sought to catch the immediate and fleeting impression (Fig. 10). It was as if they found the permanent— and what Descartes would have called the primary— forms in art, and the visual, accidental, and immediate impressions in life, and the power of their work rested in a delicate reconciliation of the two. In the Carracci Academy in Bologna students worked not only from the model but from casts of Roman reliefs and busts and a fine collection of Renaissance master drawings (Fig. 5 illustrates the great variety of sources and approaches). Though life drawing was the basic course, Agostino Carracci distrusted it because the models, with their repertory of poses, were

not close enough to life; he would pose himself, saying that only an artist was capable of imitating nature.[28] Later Bernini expressed a similar view: "If a man stands still and immobile he is never as much like himself as when he moves about; movements reveal all the personal qualities which are his alone."[29] But an essential aspect of the Carracci program was sketching done in the streets (Fig. 7) and in the countryside in order to capture the vitality that the models lacked. The rapid, impressionistic sketch, which on first sight would seem to be an adjunct of Romantic, not classic, art, became programmatic for the first time in Western Art in this milieu.[30] Here we discover the basic distinction between the Carracci and Caravaggio. No Caravaggio drawings are known; he worked directly from the model because he was not attempting to reconcile fixed and momentary forms. In the process he gained a certain vividness and precision, but he lost immediacy in movement, expression, texture, and the like. I must add that I am speaking here entirely of conscious method. Inevitably and unconsciously Caravaggio and the Carracci alike absorbed the art of the past and expressed themselves in essentially familiar images; we know from modern psychology that our perceptions are compounded of all sorts of visual experiences, and that there is no distinct borderline between the experience of art and of nature. Indeed, we cannot assimilate nature at all without some organizing

[28] C. Malvasia, *op.cit.*, I, 377f

[29] R. Wittkower, *Bernini, the Bust of Louis XIV*, London, 1951, p. 7; see also H. Brauer and R. Wittkower, *Die Zeichnungen des Gianlorenzo Bernini*, Berlin, 1931, p. 29n

[30] R. Wittkower, *The Drawings of the Carracci . . . at Windsor Castle*, London, 1952

scheme—and the artist's scheme is formed largely by art.[31]

In practice it was not important whether the classic artist started with a generalized structure and enlivened it by immediate impressions or vice versa. Poussin began his compositions with spirited sketches bathed in light and air (Fig. 10) and later disciplined them to suit his ideal.[32] Bernini reversed the process; he began a model for his bust of Louis XIV before he had observed the King, in order to establish a pose and proportion that should communicate the concept of nobility and kingship. Later he made dozens of rapid sketches of his patron on the tennis court and in cabinet meetings. In working the marble he reconciled the poles.[33]

What distinguishes the art of these great masters is that they were predisposed to form fresh perceptions of art and of life. The formulas of Idealist theory were not only philosophically and psychologically unsound, but stifled the freshness of lesser artists, who tended to abandon the polarity of immediacy and generalization and to ossify into traditional and decorous forms from the start. Furthermore, the biases of the theory for a particular kind of generalization blinded critics to the achievements of some of the greatest masters of the time—Rembrandt, Rubens, Velasquez—while its demands for lofty and instructive themes on the analogy to poetry shut out the most significant innovations which this age had contributed

[31] For the bearing of modern studies of perception on art criticism and history, see E. H. Gombrich, *Art and Illusion*, New York, 1960

[32] Poussin's theory was far more conservative than his art; see A. Blunt, "Poussin's Notes on Painting," *Journal of the Warburg and Cortauld Institutes*, 1 (1937-38), 344ff

[33] R. Wittkower, *Bernini, the Bust, passim*

to the repertory of painting—genre, landscape, and still-life. Anyone who reads the critical discussions of the French Academy in the mid-seventeenth century will realize why the only distinguished French painters of the period were those who lived far from Paris—in Italy and in the provinces.

It is a paradox typical of the age that the reactionary criticisms of the French Academy were expressed in Cartesian language and were unintentional parodies on Cartesian method. Idealist theorists could not summon Descartes to their defense without grossly distorting his intention, for his psychology actually removed the props on which their theory was founded. They took his *Passions de l'âme*[34] as a dictionary of emotions to be used by painters and sculptors of poetic themes like an anatomical atlas. Charles Le Brun, the Director of the Academy in its early days, wrote a pseudo-Cartesian treatise on the passions, which codified expression so systematically that it should have been unnecessary for artists ever again to look at a face.[35] Characteristically, the heads were drawn wherever possible from ancient sculptures and from Renaissance pictures rather than from life. In spite of superficial resemblance to Descartes' system of classification, works of this sort actually were hardly more scientific than medieval bestiaries and herbals, where the illustrations were not based on observation but on earlier illustra-

[34] Paris, 1649

[35] H. Jouin, *Charles Le Brun*, Paris, 1889, pp. 371ff (transcript of Le Brun's manuscript). The drawings for the treatise are preserved and illustrated, in part, by J. Guiffrey and P. Marcel, *Musée du Louvre et Musée de Versailles. Inventaire général des desseins de l'école française*, Paris, 1913, VIII, nos. 6447-6509

tions of the same kind. Perhaps the best known example of the academic misrepresentation of scientific method was Roger de Piles' effort to classify the great artists of the past on a scale of twenty points each for composition, drawing, color, and expression.[36]

If the academicians had read Descartes more intelligently, they would have found, as we have, the flaw in their contention that ideal forms may be selected from nature. For Descartes indicated that our visual sensations are undifferentiated and can be organized only in the mind. Ideas, that is, may be formed only inside us; they are not outside somewhere waiting to be discovered. Descartes insisted, in fact, on the unreliable nature of sense perceptions, and believed that true knowledge can be built only upon reason and is quite distinct from the false impressions gained from ordinary observation. He never wrote a word about the visual arts because he must have believed, like Plato, that since they were rooted in the senses they were inevitably misleading and irrational. But the outline of an aesthetic may be deduced from his psychology and ethics.[37] He believed that sense impressions arouse passions that had to be controlled by will, and that the good man was one who gained dominance over the passions through his reason. Furthermore, wherever reason had not penetrated to the true nature of things, he advised that one should conform to the customs and traditions of reasonable people; innovations or experiments in behavior were to be discouraged until a perfect under-

[36] E. Holt, *op.cit.*, pp. 185ff

[37] I am indebted to E. Cassirer, "Descartes und Corneille," *Descartes*, Stockholm, 1939, pp. 71-117

standing might reveal the rationality of some mode of be-
havior different from the norm.

These ethical precepts are a weak point in Descartes'
system, but we can understand how much they must have
appealed to academic art theorists; the principle that sense
data are meaningless until controlled by a rational order,
the respect for tradition, and suspicion of innovation, could
be interpreted as a call for pictorial idealism and decorum
and an attack on naturalism. The more scientific aspects
of Descartes' thought also fortified the idealists; for ex-
ample, his study of optics led him to the theory that
mass and extension are primary properties of matter, while
color, texture, and so on, are secondary or accidental, since
they result from the effects of light upon the eye. This
appeared to lend scientific sanction to the critical bias fa-
voring drawing and composition over color, an issue so
crucial that the French Academy became a battleground
in the 1670's between the official supporters of Poussin
and the renegade adherents of Rubens.[38]

In short, while Descartes destroyed the psychology of
idealist theory, he, like Galileo, gave unequivocal support
to the practice of idealist art. This is no paradox; we have
seen that the artists themselves achieved the aims of the
theory without accepting its methods, so that it was pos-
sible to admire what they did without believing what they
said.

My conclusion is entirely different from the one I an-
ticipated when I was asked to consider this subject. I had
expected to find a bond between scientific empiricism and

[38] A. Fontaine, *Les doctrines d'Art en France*, Paris, 1909, pp. 98-156

naturalism in art and discovered instead that the scientists, while they encouraged close observation, affirmed the ancient traditions of ennoblement and decorum that bound art to poetry. So we have, after all, found a certain community in seventeenth century culture, but it was due less to the influence of scientific discovery on the artist than to the influence of aesthetic and ethical traditions on the scientist. Since these traditions favored the classical forms of idealist art, the philosophy of science gave no encouragement to Caravaggio, Rembrandt, or contemporary landscape, genre, or still-life painters who had done the most to expand the limits of their art.

This conclusion is of more than local interest—it serves to call our attention to the basic difference between art and science which I mentioned earlier: that great works of art, unlike great scientific postulates, never become obsolete; in art there is no progress, but only change. For this reason there cannot have been a precise parallel to what is called the scientific revolution, since innovations in art do not overturn what came before, but *add* a fresh vision. The art and literature of the seventeenth century, whether idealized or not, constituted an enrichment of the Renaissance tradition by expanding its content and expressiveness without rejecting its principles. Since this is so, we might re-examine the theory of some historians of science that modern civilization should not be thought of as starting with the Renaissance, but with seventeenth century physics. I understand how our generation, which tends to make science the yardstick of culture, has produced such a view of history, but I cannot accept it. We

have seen that not only the artists, but Kepler, Galileo, and Descartes, contributed to the preservation of Renaissance ideals. The concept of the Renaissance itself has made it troublesome enough to understand the past without complicating it by still more artificial barriers to block our vision of the continuity of Western civilization.

Scientific Empiricism in Musical Thought

CLAUDE V. PALISCA

I N ANY discussion of science in the seventeenth century, among the names that inevitably arise are those of Galileo Galilei, Marin Mersenne, René Descartes, Johannes Kepler, and Christian Huyghens. It is no mere coincidence that these as well as other less renowned scientists —for example, Athanasius Kircher and John Wallis— were all trained musicians and authors on musical subjects. Kepler,[1] Kircher,[2] Mersenne,[3] Descartes,[4] and Christian

CLAUDE V. PALISCA is Associate Professor of the History of Music at Yale University. He is the author of *Girolamo Mei; Letters on Ancient and Modern Music* (1960), and of articles on Renaissance musical theory and esthetics in the *Musical Quarterly* (1954, 1960), *Acta musicologica* (1959), the *Journal of the American Musicological Society* (1956), and in the encyclopedia *Die Musik in Geschichte und Gegenwart*.

[1] Johannes Kepler (1571-1630) in Books 3 and 5 of his *Harmonices mundi libri v* (Linz: Godfried Tampach, 1619) dealt comprehensively with music.

[2] The most important writings on music are in Athanasius Kircher's *Musurgia universalis* (Rome: F. Corbelletti, 1650).

[3] The works on music by Marin Mersenne (1588-1648) are numerous; the most comprehensive is *Harmonie universelle* (Paris: S. Cramoisy, 1636-1637). Concerning others, see Hellmut Ludwig, *Marin Mersenne und seine Musiklehre* (Halle/Saale: Buchhandlung des Waisenhauses G. m. b. H., 1935).

[4] One of Descartes' earliest works, finished when he was only twenty two, was his *Compendium musicae* (1618; pub. Utrecht: Gisbertus à Zÿll & Theodorus ab Ackersdÿck, 1650); critical ed., C. Adam & P. Tannery, *Oeuvres* (Paris: Léopold Cerf, 1908), X, 79-150.

Claude V. Palisca

Huyghens[5] wrote important treatises on music; Galileo considered several fundamental musical questions in his scientific writings and was not only a lutanist himself, but a son, brother, and father of musicians, in short, a member of a musical dynasty. This preoccupation of scientists with music was no coincidence, because music until the seventeenth century was a branch of science and held a place among the four mathematical disciplines of the quadrivium beside arithmetic, geometry, and astronomy.

Strictly speaking, only theoretical music occupied this exalted place among the exact sciences, and until the Renaissance this aspect of music remained rather aloof from the world of practical musicianship. In the later middle ages especially, musicians tended to evolve their own rules without recourse to the traditional doctrine of musical science. In the Renaissance the mythical union of musical practice and theory that humanists ascribed to the Greeks inspired musicians to subject musical practice once again to the precepts of musical science.[6] But no sooner was a relatively satisfactory synthesis achieved, than musical art and science began to go their separate ways again.

The separation of musical art from science was an event

[5] Christian Huyghens (1629-1695), the son of the lutanist, composer, and musical theorist Constantijn Huyghens (1596-1687), made notable contributions to theoretical music, especially in the field of temperament. His *Oeuvres complètes* (The Hague: Martinus Nijhoff, 1940), X, 1-173, contain manuscript writings on music, including an early French version of the *Novus cyclus harmonicus* (pp. 141-173), the Latin version of which is in *Oeuvres* X, 169-174.

[6] Wylie Sypher has observed this same tendency in the visual arts: "The Renaissance artist, unlike the medieval artisan-builder-sculptor-craftsman, was often a doctrinaire scientist, attempting to impose upon his aesthetic world a unity, a closed system of ratios." *Four Stages of Renaissance Style* (Garden City: Doubleday & Company, 1955), p. 58.

of considerable importance for the future development of composition and musical practice in the seventeenth century. It pays to dwell upon this critical moment, toward the end of the sixteenth century, when the quadrivium exploded from its inner stresses and expanding constituents and the two disciplines, musical art and musical science, began to acquire their separate modern identities.

Meanwhile, it is important to keep in mind in analyzing music's relationship to science that music, unique among the arts, is at the opening of the scientific age inseparable from science. It is not surprising under these circumstances that the areas of musical thought most affected by the scientific revolution were those bordering on the fields of science that underwent the greatest transformation. These, it will be recalled from Professor Toulmin's lecture, were astronomy and dynamics. Astronomy, music's sister-science in the quadrivium, had until the middle of the sixteenth century bolstered the idea that earthly music contained in microcosm the divine harmony of the universe; but now there was growing evidence that the universe was not a harmony at all. In the field of dynamics the studies of the nature of vibration and of sound likewise upset many of the widely held notions of number-symbolism and of the way music affects the senses and the mind.

In considering the impact of the new cosmology and physics on music, we shall discover, as Professor Bush did in literature, that there is usually a considerable time lag between the discovery and its manifestations in artistic products. We have seen that the reactions in literature to a new discovery were often delayed a generation

at least. This is no less true with music. The scientific discoveries that were most important in determining the trends of early Baroque music were made not in the seventeenth century but in the sixteenth. Similarly, the most significant acoustical discoveries of the seventeenth century did not begin to bear fruit in musical practice until the eighteenth century. Let us review a classic case of the interrelations between music and science in this period.

The work of Jean-Philippe Rameau is surely the best example of the delayed application of seventeenth century discoveries, scientific method, and Cartesian rationalism to musical problems. Rameau's greatest contribution was probably his application of scientific method to the investigation of harmonic practice. He treated the collected musical production of his immediate predecessors and contemporaries as a body of empirical evidence, to which he added his own trials with tonal materials. From this collection of facts he derived the general laws that govern the movement of chords over a fundamental bass or root progression. As Newton had synthesized in his laws of motion a great number of observations of different movements made by himself and others, so Rameau drew from his observations of the movements of chords and melodies the fundamental laws that governed all such movements. Modern textbooks of harmony still use the concepts that Rameau first presented—the progression of chord-roots, the generation of a chord by its root, the invertibility of chords, the functional names of tonic, dominant, subdominant, dominant-seventh, and so on. Aside from its important theoretical value, the practical result of Rameau's theory, like that of any clarification of syntax, was to

94

encourage the simplification of musical language, particularly harmonic style. This became an important feature of the musical classicism of the later eighteenth century.

But Rameau was too faithful a disciple of his countryman Descartes to be satisfied with this purely empirical theory. He wished to enclose his natural laws within a rationally developed scheme of arithmetical and geometrical progressions. To be true to the Cartesian tradition, this system had to issue from a single self-evident principle[7]. This principle he found in the first six divisions of a single string, those made, that is, by dividing the string successively into halves, thirds, fourths, fifths, and sixths. The result could be represented by the series 1, $\frac{1}{2}$, $\frac{1}{3}$, $\frac{1}{4}$, $\frac{1}{5}$, $\frac{1}{6}$. By manipulating these ratios in a number of ways, Rameau attempted to rationalize the laws he had previously induced from musical facts. Never completely successful in this attempt, he kept revising his numerical progressions, falling into ever greater inconsistencies and errors. D'Alembert, a true geometrician, in making a compendium of Rameau's theories that would be comprehensible to musicians, found it expedient to throw out all of Rameau's numerical speculations, keeping only the very sound laws of harmony that the composer had induced from his rich practical experience.[8]

[7] "Music is a science which ought to have certain rules; these rules ought to be derived from a self-evident principle; and this principle can scarcely be known to us without the help of mathematics." *Traité de l'harmonie réduite à ses principes naturels* (Paris: Ballard, 1722), trans. in Oliver Strunk, *Source Readings in Music History* (New York: Norton, 1950), p. 566. For a detailed survey of the theories of Rameau, see Joan Ferris, "The Evolution of Rameau's Harmonic Theories," *Journal of Music Theory*, III (1959), 231-256.

[8] Jean Le Rond d'Alembert, *Élémens de musique, theorique et pratique suivant les principes de M. Rameau* (Paris: David l'ainé, 1752).

Claude V. Palisca

The strongest support for his theory became known to Rameau only after he had completed his first major treatise. This came not from the realm of geometry but from physical science, from the discovery of the overtones present in individual string and pipe tones. These overtones coincided with the tones produced by the first five divisions of the string and thus provided an even more natural and convincing first principle for his system than these. Moreover, it proved beyond doubt that chords are generated by fundamental bass tones. Rameau learned of the phenomenon from the papers of Joseph Sauveur,[9] and exploited its implications in his second treatise, *Nouveau systeme de musique théorique*, of 1726. Sauveur's almost definitive statement and explanation of the principle in his paper to the French Academy of Sciences, however, came only after a century and a half of investigation along two different lines: the study of the multiple sounds produced simultaneously by strings, pipes, and bells, and the study of sympathetic vibration.

Both lines of investigation are already documented in Aristotle's *Problems* on physics. There he suggests that the low tone contains its upper octave,[10] but not the reverse; he notes that as the tone produced by a vibrating string becomes weaker, the higher octave seems to sound.[11] He also observes that when a high string of a lyre that has been sounding is stopped, the string of the octave

[9] "Système général des intervalles des sons," in *Histoire de l'académie royale des sciences*, Année 1701; *Mémoires*, 2nd ed. (Paris: Charles-Etienne Hocherau, 1719), sect. IX, "Des sons harmoniques," pp. 349-356.
[10] *Problemata xix.* 918a. 8.
[11] *Ibid., xix.* 921b. 42.

below seems to resound.[12] Aristotle gives no satisfactory explanation of either phenomenon.

The first modern "breakthrough" came with Girolamo Fracastoro's explanation of sympathetic vibration of unison strings in his *De sympathia et antipathia rerum* (Venice, 1546).[13] Here Fracastoro showed that two strings of equal length stretched to the same tension will be susceptible to each other's vibrations. Fracastoro conceived of sound as a succession of condensations and rarefactions (*addensatio et rarefactio*) of the air. Thus the impulse or compression given to the air by the first string as it moves from its stationary position will be communicated to the second string. When the first string then returns to its position, rarefying the air, the second will also if it is of the same tension. Otherwise, it will impede the motion of the air produced by the first string (evidently because it takes a longer or lesser time for its rarefaction-condensation cycle). So it will cease to move. Mersenne cited Fracastoro's explanation[14] and applied it to the sympathetic vibration of strings which were not in unison but in simple ratios to each other.[15]

The second line of investigation, that of the multiple sounds of a single tone, made no headway until Mersenne and his circle began to inquire into them. Mersenne

[12] *Ibid.*, *xix.* 919b. 24; 921b. 42.

[13] *De sympathia et antipathia rerum liber unus,* cap. *xi, Opera omnia,* 2nd ed. (Venice: Juntas, 1574), pp. 66-67. See also cap. *iv* for his general theory of sound.

[14] Marin Mersenne, *Harmonicorum libri* (Paris: Guillaume Baudry, 1635), Bk. IV, prop. *xxvii,* pp. 65-68.

[15] Descartes reported observing this kind of sympathetic vibration in his *Compendium* (*Oeuvres* X, 97), but his explanation of it is insufficient; nor is Beeckman's, quoted in *ibid.,* 52, any better.

first noted the presence of a plurality of tones in the vibration of a single string in the early 1620's. Later he recognized that what he heard were the upper octave, twelfth, fifteenth, seventeenth, and twentieth.[16] When he queried his scientific friends, as he was accustomed to do, for an explanation of the phenomenon, they put forward different theories. Isaac Beeckman suggested that the thickness of the string must have been uneven and caused the particles of air around it to vibrate at different rates.[17] Descartes put forward the theory that in sounding bells some parts vibrate faster than others.[18] None of these reasons satisfied Mersenne, and he acknowledged that this was the most difficult problem he had encountered in his study of sound.

[16] In *Quaestiones celeberrimae in Genesim* (Paris: sumptibus Sebastiani Cramoisy, 1623), cap. IV, Quaest. LVII, Art. III, col. 1560, Mersenne tells of hearing a string emit several tones at once, as if it were simultaneously vibrating in a number of ways, but the tones were too confused and fleeting to be identified. In the "Fourth Book on Instruments" of the *Harmonie universelle*, prop. *ix*, however, he identifies the component sounds, saying that he has experienced more than a hundred times that when a single string is struck there are sounded, besides the natural pitch of the string, five other tones: the upper octave, twelfth, fifteenth, seventeenth, and twentieth, giving the series C c g c' e' a'. In the *Harmonicorum libri*, Lib. I, *xxxiii*, 54, he claims to have detected also the twenty third (d").

In his *Compendium*, Descartes had already remarked that the octave is always somehow present in any tone: "existimo, nullum sonum audiri quin huius octava acutior auribus quodammodo videatur resonare." Lloyd P. Farrar has dealt comprehensively with the history of the phenomenon of overtones in his Master's thesis, "The Concept of Overtones in Scientific and Musical Thought (Descartes to Rameau)," University of Illinois, 1956.

[17] Letter of May 30, 1633, in Mersenne, *Correspondance* (Paris: Presses Universitaires de France, 1946), III, 403.

[18] Letter of February 25, 1630, in Mersenne, *Correspondance*, II (1936), 397.

It was only when the two lines of research were united into a single experiment by John Wallis that the true cause was discovered. In 1673 William Noble of Merton College, Oxford, and Thomas Pigot, of Wadham College, Oxford, showed experimentally that when strings tuned at the octave, twelfth or seventeenth below a previously sounding string vibrated sympathetically, they produced unisons to the sounding string by vibrating in aliquot parts. This was shown by placing paper riders on the sympathetic strings at the points where, if the string were stopped, unisons would be produced. The paper riders remained still, showing that the strings were vibrating in parts. A few years later, Wallis applied this knowledge to the study of the vibration of a single string and observed that a clear and multiple sound would occur only when the points of no vibration (called nodes) were not disturbed by plucking at these points.[19] Thus partial vibration was shown to be characteristic of single sounds and to be the cause of overtones.

The history of the investigation of the overtone series presents a striking example of the concurrent labor of scientists and musicians in the search for an explanation of a mysterious phenomenon. Without the persistent inquiries of Mersenne, a trained musician gifted with an acute ear, the problem would probably have gone unrecognized for some time. Similarly, it was another man learned in music, John Wallis,[20] who recognized how the

[19] *Philosophical Transactions*, XII (April 1677), 839-842. See also A. Wolf, *A History of Science, Technology, and Philosophy in the 16th and 17th Centuries* (New York: Harper Brothers, 1959), I, 283-285.

[20] Wallis edited the Greek texts of the *Harmonics* of Ptolemy, the

experiments in sympathetic vibration made by his colleagues of the Royal Society were relevant to the problem of the overtones. Finally, it was a Frenchman, Sauveur, interested in methods of tempering instruments who transmitted the theory to our musical theorist Rameau.

The theory of Rameau, then, is a good illustration of the slowness with which scientific facts were absorbed into artistic theories once music had been separated from science. Therefore, if we are to observe scientific developments that influenced the course of musical history in the seventeenth century, we must seek them in the preceding period. There, because of the closer rapport between music and science, we shall find that the problems subjected to scientific, or at least objective, investigation were not the most fundamental, but were those that demanded solution for practical reasons. In the seventeenth century, the age of the emergence of instrumental music, it was natural that attention should be focused on the components and characteristics of the tones of pipes and strings; and in the preceding period, during which composers broke the bounds of the diatonic, modal, and consonant vocal idiom, it was characteristic that scientific discussion should be concentrated on the nature of the consonances and dissonances and their changed relationships in the new chromatic spectrum.

When Claudio Monteverdi replied to the critic Giovanni Maria Artusi in a famous declaration of faith printed in the fifth book of madrigals in 1605, Monteverdi ac-

commentaries upon them by Porphyry, and the *Harmonics* of Manuel Bryennius.

knowledged that his manner of using dissonances was the crucial issue in the controversy about the new and old styles. The established considerations for the use of consonances and dissonances as taught by Zarlino,[21] he said, were now superseded by a second scheme, and this constituted a *seconda pratica*. This modern manner of composition, he added, was founded on truths supportable by both reason and sensation. What he implied was that the products of the new practice were not a haphazard harvest of men who sow and toil without design. But, he emphasized, neither were they products of a new theory. For theory in the old sense of a musical science dictating to practice was dead. Monteverdi promised to write a treatise about the new practice, but he never did so.

It was a discouraging task for anyone to undertake. The older system had collapsed and it would take years of experience with the expanded resources before a new one could be erected. And no new system appeared until that of Rameau. The scientific revolution played a part in the demise of the old system as well as in the foundation of the new.

To appreciate the change in attitude toward consonance and dissonance fostered by the discoveries in the nature of sound, it is necessary to understand the traditional explanations of them. The identity of the purest consonances with the simplest ratios was observed very early in the history of science. If the ratios of the principal consonances did not actually inspire Pythagorean numerology, they were certainly among its strongest pillars. The consonances recognized by the ancients were the octave, pro-

[21] Gioseffo Zarlino, *Le istitutioni harmoniche* (Venice, 1558).

Claude V. Palisca

duced by string lengths in the ratio of 2:1, the fifth, by 3:2, and the fourth, by 4:3. Medieval polyphony accorded at least practical recognition to consonances outside the sacred precinct of the first four numbers. It was therefore the task of the theorists of the fifteenth and sixteenth centuries to find a justification for the major and minor thirds and sixths. The most eloquent spokesman, if not the author, of the new numerology was Gioseffo Zarlino (1517-1590). He extended the realm of consonance to combinations produced by the ratios within the first six numbers, the *senarius* or *senario*. He took great pains to show that within the frame of the Neo-Pythagorean and Neo-Platonic ideology the number six was quite as sacred as the number four. It was the first perfect number, which means that it is the sum of all the whole numbers of which it is a multiple: $1 + 2 + 3 = 1 \times 2 \times 3 = 6$. The number six possessed many other metaphysical virtues that Zarlino enumerates. The enlarged sacred precinct now included the previously excluded major third (5:4), minor third (6:5), and major sixth (5:3). Zarlino also contingently admitted the minor sixth, although its ratio (8:5) was outside the first six numbers.[22]

Οὐδέν χωρίς ἐμόν, "nothing without me," that is, proportion, was the motto on Zarlino's personal device, which shows a cube inscribed by various lines that intersect to form the ratios of the consonances (see Plate I).[23] Below the cube

[22] *Ibid.*, I, *xiv-xvi.*

[23] Giovanni Maria Artusi, *Impresa del Molto Rev. M. Gioseffo Zarlino . . . dichiarata* (Bologna: G. B. Bellagamba, 1604). Contrary to what one reads in most sources, including the articles on Artusi in *Die Musik in Geschichte und Gegenwart*, Vol. I (1951), col. 748, and in *Baker's Biographical Dictionary* (5th ed.; 1958), this is not an attack

is the legend, ἀεί ὁ αὐτός, "always the same," which indicates the permanence and universality of this system of proportions.

The "sounding numbers" of the *senario* constituted in Zarlino's mind a divinely ordained natural sphere within which the musician could operate freely to produce the main fabric of his compositions. Outside the safe sanctuary of the *senario* was the wilderness of dissonances, some of which could be brought into a composition under certain restrictive conditions to embellish and underscore the effect of the consonances. In his monumental *Harmonic Institutions* of 1558, Zarlino developed the rules of composition based on these premises. The treatise's mathematical underpinning and theological overtones won it the acclaim of both the pseudo-scientific and religious. Although Zarlino had merely summed up the polyphonic practice of his immediate predecessors, the imprimatur he gave to this particular practice tended to discourage experiments in the use of the illicit intervals. Many were of the opinion that musical composition had at last reached perfection of method. Little, indeed, was added to the theory of strict counterpoint during the next century and a half.

But during the one hundred years after Zarlino's text was published, the premises upon which his theory rested were undermined by a number of scientific discoveries, demonstrations, and hypotheses. The first wedges to pry musical theory loose from its numerological foundations were already driven in the sixteenth century.

on Zarlino but a eulogy in the form of an explanation of his personal device printed after Zarlino's death by his most loyal pupil.

Claude V. Palisca

The cause of consonance, or at least its formal cause in the terminology of Aristotelian analysis, was generally stated to be the *numerus sonorus* or harmonic number. Until the sixteenth century no attempt had been made to study the process whereby a numerical ratio became a pleasing sensory experience. It sufficed to believe that the soul, which was considered a harmony of diverse elements, should be pleased by a similar harmony in the sounding numbers.

Perhaps the first to investigate the mechanics of the production of consonances was Giovanni Battista Benedetti. He was born in Venice in 1530 and died in Turin in 1590. Between 1558 and 1566 he was a lecturer in mathematics in Parma under the patronage of Duke Ottavio Farnese. It was here that he probably met the composer Cipriano de Rore, who was choirmaster to the duke between 1561 and 1562. In 1567 Benedetti moved to Turin, where he was court mathematician for the dukes of Savoy and lecturer at the university.[24] Benedetti worked on a great variety of geometrical, mathematical, astronomical, and mechanical problems, including the acceleration of falling bodies, where his studies anticipated those of Galileo. He

[24] Giovanni Bordiga, "Giovanni Battista Benedetti, filosofo e matematico veneziano del secolo XVI," in *Atti del Reale Istituto Veneto di Scienze Lettere ed Arti*, Anno 1925-1926, Vol. LXXXV, Part 2, pp. 585-754. Benedetti seems to have lectured also in Rome during the academic year 1559-1560, for Girolamo Mei reported to Piero Vettori in a letter of the last of August 1560 (Br. Museum Add. 10,268, fols. 214r-215r) that he had heard a Dottor Benedetti, about 30 to 34 years of age, read the natural science, *De coelo*, and *De generatione animalium* of Aristotle, but had missed him read the *Physics* that same winter. Mei praised Benedetti highly for his fluency, memory, languages, acumen, and independence of mind. Benedetti's name does not appear in any of the official lists of professors at Rome that year, however.

was also an amateur musician and composer and was interested in the problem of tuning instruments. In his major work, *Diversarum speculationum mathematicarum & physicorum liber*, 1585, several questions concerning sound and music are considered. The most interesting discussions to us are those in two undated letters addressed to Cipriano de Rore printed in this book. They were probably written around 1563.[25]

[25] *Diversarum speculationum mathematicarum & physicorum liber.* Taurini, apud Haeredem Nicolai Bevilaquae MDLXXXV. The last part of this work, headed "Physica, et Mathematica Responsa," contains replies of which he had kept copies to queries by various persons on topics in physics, astronomy, geometry, mathematics, and music. Ms copies of the letters, some with annotations in Benedetti's hand, were in Ms LXXXIII. N. II. 50 and CXIV. N. III. 27 of the Biblioteca Nazionale of Turin, but were destroyed by fire; see Bordiga, *op.cit.*, p. 613, and Benedetti, "Ad lectorem," in *Diversarum*, p. 204. The two letters on music are under the heading, "De intervallis musicis," and are both addressed to "Cypriano Rorè Musico celeberrimo," but they give no indication of date or place. The first letter (pp. 277-278) demonstrates with the aid of seven three-part examples in score how false intervals are produced through the introduction of chromatic alterations in a diatonic system. The second letter, headed "De eodem subiecto. Ad eundem," pp. 279-283, presents further examples and considers several modes of temperament that aim to circumvent this difficulty. Finally there is the section on the cause of consonance. The two letters have been reprinted by Josef Reiss in "Jo. Bapt. Benedictus, *De intervallis musicis*," *Zeitschrift für Musikwissenschaft*, VII (1924-1925), 13-20, but with hardly any comment. They are summarized in Bordiga, *op.cit.*, pp. 724-726, though again without any appreciation for the importance of Benedetti's theory of consonance.

By a number of known facts the period during which the letters might have been written may be narrowed down to the two years between 1562 and 1564. The positive boundary dates are 1558, the date of Zarlino's *Istitutioni harmoniche*, mentioned in the second letter, p. 281, and 1565, the year de Rore died. Benedetti probably became acquainted with the composer when de Rore came to Parma in 1561 to take the post of Maestro di Cappella to Duke Ottavio Farnese. In 1562 de Rore became Maestro di Cappella at San Marco in Venice, returning

In the second of these letters Benedetti inquires—possibly for the first time—into the relation between the sensation of pitch and consonance and rates of vibration. In introducing this subject he says he wishes to speculate about the way the simple consonances are generated. They arise, he says, from a certain equalization of percussion *(aequalitione percussionum)*, or from an equal concurrence of air waves *(aequali concursu undarum aeris)*, or from their co-termination *(conterminatione earum)*. The unison, he continues, is the first and most agreeable consonance, and after it comes the diapason or octave, then the fifth. Now, these preferences may be shown to be the result of the "order of agreement of the terminations of the percussions of the air waves, by which the sound is generated."[26]

In the unison the air waves agree perfectly without any interference *(intersectione)* or fractioning *(fractione)*. This may be demonstrated by dividing the string of a monochord into two equal parts. He then continues:

Sed cum ponticulus ita diviserit chordam, ut relicta sit eius tertia pars ab uno latere, ab alio verò, duae tertiae, tunc maior pars, dupla erit minori, et sonabunt ipsam diapason consonantiam, percussiones vero terminorum ipsius, tali proportione se invicem habe-	But when the bridge so divides the string that a third of it remains on one side and two thirds on the other, then the larger part is twice the smaller and the two will sound the consonance of the octave. The percussions of the boundary-tones of this octave

to Parma in 1564. The period of de Rore's absence from Parma—1562 to 1564—therefore seems the most likely for the two letters.

[26] Page 283: "Videamur igitur ordinem concursus percussionum terminorum, seu undarum aeris, unde sonus generatur."

bunt, ut in qualibet secunda percussione minoris portionis ipsius chordae, maior percutiet, seu concurret cum minori, eodem temporis instanti, cum nemo sit qui nesciat, quod quo longior est chorda, etiam tardius moveatur, quare cum longior dupla sit breviori, et eiusdem intensionis tam una quam altera, tunc eo tempore, quo longior unum intervallum tremoris perfecerit, brevior duo intervalla conficiet.

Cum autem ponticulus ita diviserit chordam, ut ab uno latere relinquantur duae quintae partes, ab alio verò tres quintae, ex quibus partibus generatur consonantia diapente; tunc clarè patet, quod eadem proportione tardius erit unum intervallum tremoris maioris portionis, uno intervallo tremoris minoris portionis, quam maior portio habet ad minorem; hoc est tempus maioris intervalli ad tempus minoris erit sesquialterum; quare non convenient simul, nisi perfectis tribus intervallis minoris portionis, et duobus maioris; ita quod eadem proportio erit numeri intervallorum minoris portionis ad intervalla maior-

will have between them such a proportion that in every second percussion of the minor portion of this string, the larger will percuss or concur with the minor at the same instant of time. For everyone knows that the longer the string, the more slowly it is moved. Therefore, since the longer part is twice the shorter, and they are both of the same tension, in the time that the longer completes one period of vibration, the shorter completes two.

Now if the bridge so divides the string that two fifths remain on one side and three fifths on the other, the consonance of the fifth will be generated. It is clear that a single period of vibration of the larger portion will take more time than one period of the smaller portion by the same proportion as exists between the major portion and the minor. That is, the ratio of the duration of the major portion to that of the minor will be sesquialtera. Therefore they will not convene at one instant until three periods of the minor portion and two of the major have

is, quae longitudinis maioris portionis ad longitudinem minoris; unde productum numeri portionis minoris ipsius chordae in numerum intervallorum motus ipsius portionis, aequale erit producto numeri portionis maioris in numerum intervallorum ipsius maioris portionis; quae quidem producta ita se habebunt, ut in diapason, sit binarius numerus; in diapente verò senarius; in diatessaron duodenarius, in hexachordo maiori quindenarius; in ditono vicenarius, in semiditono tricenarius, demum in hexachordo minori quadragenarius; qui quidem numeri non absque mira ili analogia conveniunt invicem.[27]

been completed. It follows that the ratio between the number of periods of the minor portion and that of the major will be the same as the ratio between the lengths of the two portions. Therefore the product of the number of the minor portion of the same string and the number of periods of the same major portion will be equal to the product of the number of the major portion and the number of periods of the same major portion. These products will be therefore: for the diapason, 2; for the fifth, 6; for the fourth, 12; for the major sixth, 15; for the ditone [major third], 20; for the semiditone [minor third], 30; finally for the minor sixth, 40. These numbers agree among themselves with a certain wonderful logic.

This passage contains several statements of primary importance in the history of acoustics. First, Benedetti states the law that the ratio of the frequencies of two strings

[27] *Ibid.* This system is the ancestor of a number of later attempts at grading intervals, from the grades of suavity of Leonhard Euler in *Tentamen novae theoriae musicae* (Petropoli: Typographia Academiae scientiarum, 1739) to Paul Hindemith's classes of chord intensity in his *Craft of Musical Composition* (New York: Associated Music Publishers, 1942), I.

ΟΥΔΕΝ ΧΩΡΙΣ ΕΜΟΥ.

ΑΕΙ Ο ΑΥΤΟΣ.

Plate I

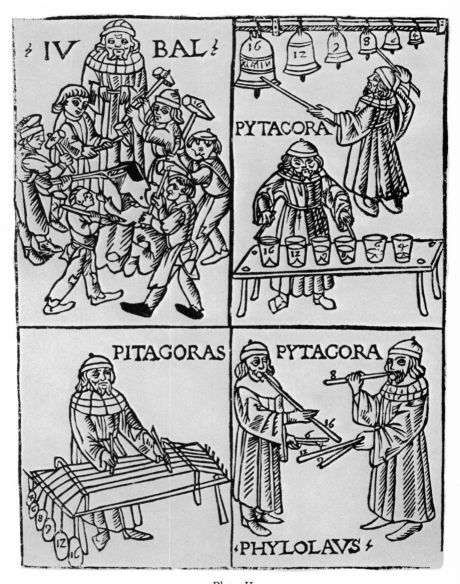

Plate II

varies inversely with their lengths, the tension being equal. He does not show how he arrived at this conclusion or how he managed to compare the rates of vibration. Only in the seventeenth century was the truth of his observation adequately demonstrated. Second, Benedetti shows that the concordance of intervals depends on the coincidence of the terminations of vibration-cycles. These moments of no vibration will concur every two vibrations of the shorter string in an octave, every three of the shorter string against one of the longer in a twelfth, and so on. Thirdly, Benedetti arrives at an index of the degree of agreement in a consonance by multiplying the two terms of its ratio. He is thus able to express the standing of each of the consonances in a descending scale of concordance.

Benedetti's discovery was potentially a fatal blow to number symbolism. When consonance is understood as the frequent concurrence of the termination points of vibrations, the distinction between consonance and dissonance becomes one of relative frequency of concordance. There is no sudden falling off of this agreement of waves when the bounds of the mystic number six are overstepped. Nor is any clear boundary discernible anywhere in the infinite series of musical intervals. Moreover, if one were to pursue Benedetti's scale of concordance beyond the so-called consonances to the dissonances, one would have to recognize that the number for the diminished fifth ($7:5$)—35—is between that of the minor third, 30, and that of the minor sixth, 40. This puts the diminished fifth, rejected by Zarlino, ahead of the minor sixth, which, though outside the *senario* (because of its ratio $8:5$), he somehow rationalized into his system. While Benedetti failed to

draw these obvious conclusions from his ranking of the consonances, his scepticism of the exclusiveness of the *senario*, revealed in another demonstration (to which we shall come presently), leads one to believe he was aware of these implications of his theory.

Benedetti's voice found few echoes in the intellectual void of the reigning Pythagoreanism. But his point of view gained momentum during the next hundred years, and by the middle of the seventeenth century it held the field at least among progressive musicians.

One of the earliest supporters of the empiricist view was Galileo's father, Vincenzo Galilei (c. 1520-1591), a renowned lutanist and musical theorist. Galilei laid aside all numerological grounds for the classification of consonance and dissonance. He worked out a new ranking on the basis of pure sense experience and artistic usage. The octave, fifth, thirds, and sixths came first; only then followed the fourth, which was subject to restrictions in composition. Then came the augmented fourth and diminished fifth in a category intermediate between the dissonances and imperfect consonances.

In the second and third decades of the seventeenth century the question of the ranking of consonances became the subject of a lively debate between Marin Mersenne and René Descartes. It was Isaac Beeckman, rector of the college of Dordrecht, who in 1618 had shown Descartes a demonstration of the correspondence between the wave motions of consonances. Though his explanation was almost identical to Benedetti's, Beeckman had probably arrived at it independently, as so often happens in scientific

research.[28] Mersenne accepted this as proof that the relative pleasingness of consonances was caused by the concurrence of the "returns" of vibrations. Descartes, however, remained sceptical of this as an explanation of the subjective reaction of a listener to the various consonances. In a letter to Mersenne of December 18, 1629, Descartes wrote: "As for your manner of determining the goodness of consonances, . . . it is too subtle, if I dare say, to be distinguished by the ear, without which it is impossible to judge the goodness of any consonance, and if we judge by reason, this reason must always consider the capacity of the ear."[29]

In a subsequent letter, in the middle of January, 1630, Descartes added: "All this calculation serves only to show which consonances are simpler, or if you wish, the sweetest or most perfect, but not for that the most pleasing."[30] For the fifth is generally regarded as more agreeable than the twelfth, although in the twelfth the frequency of concurrence is twice that of the fifth. Finally on January 13, 1631, Descartes concluded:

"Concerning the sweetness of consonance, there are two things to be distinguished, that is, what makes them simpler and more concordant *(accordantes)* and what makes them more pleasing *(agréable)* to the ear.

"Now, as for what renders them more pleasing, this

[28] See Descartes, *Oeuvres* X (1908), 57, and Mersenne, *Correspondance*, I, 606. In a letter to Mersenne of January 13, 1631, Descartes presents a diagram that shows the concurrence of the vibrations of a tone with its upper octave, twelfth, eleventh, and tenth, and the mutual concurrence of the other tones among themselves: Mersenne, *Correspondance*, III, 26.

[29] *Ibid.*, II, 338. [30] *Ibid.*, II, 371.

depends on the places where they are employed, and there are places where even the diminished fifths and other dissonances are more pleasing than the consonances, so it is not possible to determine absolutely that one consonance is more pleasing than another. One may say, surely, that the thirds and sixths are generally more pleasing than the fourth, that in gay compositions the major thirds and sixths are more pleasing than the minor, and the contrary in sad compositions, etc., since there are more opportunities to use them pleasingly.

"But we can say absolutely which consonances are simplest and most concordant, because this depends only on whether their tones unite better and approach more closely the nature of the unison. So we can say absolutely that the fourth is more concordant than the major third, even though ordinarily it is not more pleasing, in the same way that senna *(la casse)* is sweeter than olives, but not more pleasing to our taste."[31]

Descartes' distinction between concordance or simplicity and pleasingness recognizes the separation of objective and subjective that will be a recurrent theme in our study. To leave to the scientist the investigation of acoustical truths and to the musician the manipulation of sonorous combinations seems to us today only common sense; yet this simple rule gained acceptance only after many battles. Mersenne, after resisting Descartes' conclusions for a time, finally resolved the question in the *Harmonie universelle* in the manner put to him by his correspondent Descartes.[32]

Yet on this question neither Descartes nor Mersenne

[31] *Ibid.*, III, 24-25.
[32] "Traitez des consonances," Bk. I, prop. *xix*, p. 66.

ventured so far into pure empiricism as did Christian Huyghens. Huyghens contemplated the extension of the range of consonance to include the dubious ratios involving the number seven: the tritone or augmented fourth (10:7) and the diminished fifth (7:5). At least he saw no reason for excluding them. Huyghens compared the status of these intervals in his time to that of the thirds and sixths in ancient times. The latter intervals were regarded as dissonances then only because of their relative unfamiliarity. Just as these became recognized consonances, so would the augmented fourth and diminished fifth in time be welcomed among them.[33] Not long after, indeed, the forms of the dominant seventh chord, which contain these dubious intervals, became recognized harmonic entities that needed no special preparation.

Let us now return to the letters from Benedetti to de Rore printed in the *Diverse Speculations* of 1585. We have already considered the last part of the second letter. In the scientist's first letter and in the first part of the second Benedetti's purpose was to show the composer why a system of equal temperament was a necessity for modern music. The importance of what Benedetti has to say on this subject does not lie in any new facts presented, but in his scientific attitude toward a question which was rife with prejudices. The two tunings that had received theoretical sanction up to now, the Pythagorean, sponsored by Boethius and his followers, and the syntonic diatonic of Ptolemy, advocated by Giovanni Spataro, Lodovico Fo-

[33] Huyghens, *Nouveau cycle harmonique*, in *Oeuvres*, XX, 162-164.

gliano, and Zarlino,[34] were both originally devised for purely melodic music, such as that of a voice singing alone, or in unison with other voices or instruments. When either of these tunings was used in polyphonic music, many difficulties arose because of their unequal tones or semitones, or their harsh-sounding consonances on certain steps of the scale. From earliest times instrument builders and tuners compensated for these shortcomings by tempering the consonances by ear. Theorists after post-classical times, however, generally evaded the problem. But the coalescence of theory and practice in the Renaissance made coming to terms with this issue imperative. Thus the problem of tuning became the subject of the most heated musical controversies in the fifteenth and sixteenth centuries. Musically-minded scientists and scientifically-minded musicians were at the head of those who faced the new challenge.

It is in this context that Benedetti wrote to de Rore. He wanted to prove that whenever a composer writes certain intervallic progressions or introduces chromatic steps in a part, singers or players cannot maintain the true intervals without causing the pitch to rise or fall by a minute amount. He supported his contention with a number of

[34] Spataro in *Errori de Franchino Gafurio* (Bologna: Benetictus Hectoris, 1521), Part IV, Error 26, had already suggested that the syntonic diatonic of Ptolemy would remove many of the faults inherent in the Pythagorean tuning, and in Pt. V, Err. 16, stated that this syntonic was in fact the tuning used by practical musicians. Spataro's teacher Bartholomé Ramos de Pareja, in his *Musica practica* (Bologna, 1482), had broken the ground for the acceptance of justly tuned thirds and sixths. Later Lodovico Fogliano took up the advocacy of the Ptolemaic syntonic tuning in *Musica theorica* (Venice: Io. Antonius & fratres de Sabio, 1529). See my articles, "L. Fogliano" and "Ramos de Pareja," in the encyclopedia, *Die Musik in Geschichte und Gegenwart*.

examples: seven one-measure, three-part progressions in the first letter and two longer examples in the second letter. The second of the longer examples repeats four times a two-measure progression containing one chromatic alteration. If the theoretically true tuning of the consonances is maintained through the common tones that link one interval with the next, the pitch will fall one syntonic comma during each statement, totaling at the end of Benedetti's example nearly a full semitone (or, more precisely, 88 per cent of an equal tempered semitone). The first three and one-half measures of his example are given below (Figure 1). The ratios which appear in my example stand for the intervals named by Benedetti in the text of his letter.[35]

Figure 1

[35] *Ibid.*, p. 280: "in prima cellula discedens bassus à quinta cum superiori, & ab unisono cum tenore discedens ad tertiam minorem cum ipso tenore, facit cum superiori septimam maiorem, quae est ut .9. ad .5. superquadripartiensquintas scilicet, à qua discedens postea superius, ut faciat cum bassu sextam maiorem, descendit per semitonium maius, à qua sexta maiori descendens bassus, & ascendens per quartam, efficit cum dicto superiori tertiam maiorem, à qua discedens superius ut efficiat quartam cum ipso bassu (qui quidem bassus transit in tenorem) ascendit per semitonium minus, differens à semitonio maiori per unum comma, unde cantilena remanet depressa per unum comma, cum deinde idem faciat inter tertiam, & quartam cellulam, per aliud comma descendit, & sic toties facere posset, ut postremo valde deprimatur cantilena à primo phthongo."

Claude V. Palisca

Benedetti's proof may be stated as follows:

$$3/2 \times 6/5 = 9/5$$
$$9/5 \div 5/3 = 27/25$$

Therefore the soprano descends 27/25, a large semitone.

$$5/3 \div 4/3 = 5/4$$
$$4/3 \div 5/4 = 16/15$$

Therefore the soprano in the second measure ascends 16/15, a small semitone.

$$27/25 \div 16/15 = 81/80, \text{ a syntonic comma.}$$

Therefore in the first two measures the pitch has fallen a syntonic comma.

Benedetti noted that de Rore had made such a departure from a diatonic mode when he introduced semitone motion at the words "Les yeulx en pleurs," in the chanson "Hellas comment voules-vous" (1550).[36] If we follow Benedetti's method and divide the ratios over the common tones to get the sizes of the semitones, the succession of semitones in the soprano part is 16:15, 25:24, 16:15. Multiplying these ratios, we get for the total descent of the soprano part a minor third in the ratio 32:27. This is one syntonic comma smaller than the true minor third, 6:5. Therefore, the pitch will have risen one syntonic comma, 81:80, or 22 per cent of an equal tempered semitone, between the G of the tenor and the same G in the alto a

[36] *Ibid.*, p. 278. The chanson is published in Gertrude Parker Smith, ed., *The Madrigals of Cipriano de Rore for Three and Four Voices* (Northampton, Mass.: Smith College, 1943), pp. 84-89. It was first printed in *Il primo libro de madrigali a 4 voci* (Ferrara: Buglhat & Hucher, 1550).

measure later. Since the passage sung here by the soprano is heard in three other voices, the pitch will have risen at the end of the section on the words "Les yeulx en pleurs"—nearly a semitone.

Figure 2

Benedetti further shows that purely diatonic music is not free from such pitfalls. In the perfectly innocuous progression of the first two measures of the example below, the pitch rises one syntonic comma if the true fourth and fifth are used over the alto's common tone D in the first measure and the true fifth and minor third in the following measure over the alto's E. By the ninth measure the pitch has risen four syntonic commas.[37]

[37] *Ibid.*, p. 279: ". . . in prima figura, ubi superius à .g. primae cellulae ad .g. secundae, interest unum comma, eo quod progrediens superius in prima cellula ipsius cantilenae à quarta ad quintam cum tenore, ascendit per tonum sesquioctavum, à prima cellula deinde ad secundam, tenor ascendit similiter per tonum sesquioctavum cum transeat à quinta ad quartam, quod facit cum superiori, in secunda cellula postea, cum superius descendat à maiori sexta ad quintam, quod facit cum bassu, seu à quarta ad tertiam minorem, quod facit cum tenore, tunc descendit per tonum sesquinonum, ita quod non revertitur ad eundem phthongum, ubi prius erat in prima cellula, sed reperitur per unum comma altius, quod quidem comma est differentia inter tonum sesquioctavum & sesquinonum, ut alias tibi demonstravi."

Figure 3

In the first two cases the cause of the difficulty is an inequality of semitones, in the third case, an inequality of whole tones. The solution to the problem is obviously equal semitones and tones, or what is called equal temperament. The demonstration also proves, as Benedetti states at the beginning of this letter, that a composition need not end in the tone in which it began, that this in fact is almost an impossibility. Thus one of the cardinal rules of the orthodox theory is nullified.

In the above examples, the performance will continue on an even keel only if the true intervals of the *senario* recommended by Zarlino are abandoned through judicious adjustments by the singers. A system of temperament thus becomes a necessity. Temperament was already tolerated in the tuning of the lute and keyboard instruments, but whether it should be countenanced in purely vocal music was a burning issue at this time. It was the issue, in fact, that most clearly divided the Neo-Platonists like Zarlino from the empiricists in the decades preceding the seventeenth century. Benedetti probably addressed his letter to de Rore because he knew that this composer would be responsive to his ideas, for de Rore was the recognized leader of the avant-garde of his generation and was con-

spicuous in his use of harmonies outside the immediate range of the traditional diatonic church modes.

Zarlino's opposition to temperament for vocal music grows out of his rationalistic classification of consonances. Since he rejects the ratios outside the *senario*, the only acceptable tuning is that which was first described by the Greek theorist Dydimus and later modified and named syntonic diatonic by Ptolemy. Nearly all the consonances between the tones of a diatonic scale tuned to this system are in their simplest ratios and will sound true to the ear. Such a system is also called just intonation. Zarlino admitted that certain instruments that had to be played in a number of keys (harpsichords, organs, lutes, fretted viols) could not do without temperament in some form. But voices and instruments with flexible tuning were free of this necessity. His argument is typically mystic:

"If it were true that in voices as well as in instruments we only hear consonances and intervals out of their natural proportions, there would follow that those born of the true harmonic numbers would never find realization in fact but would exist always potentially. These potentialities would be wasted and frustrated, for any natural potentiality which is not reduced to action at some time is without any utility in nature. And yet we see that God and Nature never do anything in vain. Therefore it is necessary to say that this potential is at some time reduced to action.[38]

This defense of just intonation reminds one of Kepler's reply to a question that must have seemed to his contemporaries, if not to us, altogether theoretical: Is the planet

[38] *Istitutioni harmoniche,* II, *xlv.*

Jupiter inhabited? It must be so, said he, and moreover some day we shall fly there, for what good will it do to have four moons coursing about Jupiter if there is no one on that planet to watch them?[39] Neither Kepler nor Zarlino had yet given up the notion that all of nature exists simply for the benefit of man.

A more thorough refutation of Zarlino's position than Benedetti's was undertaken by Vincenzo Galilei in his *Dialogo della musica antica et della moderna*.[40] Galilei had been a pupil of Zarlino in Venice around 1564, having been sent there by his humanist patron Count Giovanni Bardi to acquire a mastery of theoretical music. As a popular lute player and singer, Galilei used to frequent the Count's home, where an academy, later known as the "Camerata," was accustomed to meeting. Upon his return from his study with Zarlino, Galilei taught his master's doctrine for a while to the noblemen of Bardi's circle. But after a period he became dissatisfied with certain of Zarlino's solutions to important theoretical questions, and, encouraged in this opposition by another humanist, Girolamo Mei, Galilei became Zarlino's most outspoken and severest critic. There is no known direct connection between Benedetti and Galilei, but Mei knew both of them, and Benedetti's lectures on Aristotle probably reinforced Mei's native scepticism, which, as will be seen, exerted a decided influence on Galilei.

In the first pages of the *Dialogue*, Galilei disposes of both the syntonic diatonic of Ptolemy and the diatonic

[39] Lynn Thorndike, *A History of Magic and Experimental Science* (New York: Columbia University Press, 1958), VII, 13.

[40] Florence: G. Marescotti, 1581.

ditoniaion—so-called Pythagorean tuning—advocated by
the Boethians. He shows that in the syntonic tuning not
only are the consonances formed between the natural tones
of the diatonic scale and such tones as Bb, F♯, and C♯
not in their true ratios, but certain combinations within
the diatonic system itself also do not conform to these
true ratios.[41] One example will suffice: the minor third,
D-F. The first four tones of the syntonic diatonic scale
are separated by the following intervals:[42]

C	D	E	F
major tone	minor tone	major semitone	
9/8	10/9	16/15	

To get the ratio of D-F we multiply 10/9 by 16/15,
which is 160-135, or 32/27. This is smaller than the minor
third (6:5) by a syntonic comma (81:80).[43] Thus the syn-
tonic tuning is shown to be inadequate even aside from
the difficulties introduced by the use of simultaneous con-
sonances or chromaticism.

Zarlino's tenacious adherence to the syntonic tuning as
the basis for the ideal medium of vocal music in the en-
suing controversy shows that this loyalty was merely a
symptom of a deeper credulity, of a philosophic nature. It
was at this that Galilei directed his subsequent attacks.
He aimed to reveal the fallacy, for example, of the prem-
ise that some intervals were natural because they had sim-
ple ratios, while others were unnatural. "Whether we sing

[41] *Ibid.*, pp. 4ff. [42] Zarlino, *op.cit.*, II, *xxxix.*
[43] Galilei, *Dialogo*, p. 10.

the fifth in the 3:2 ratio or not," Galilei argued, "is of no more importance to Nature than that a crow or a raven lives three hundred or four hundred years and a man only fifty or sixty."[44] "Among the musical intervals," he declared in another place, "those contained outside the *senario* are as natural as those within it. The third contained in the 81:64 ratio is as natural as that in the 5:4 ratio. For the seventh to be dissonant in the 9:5 ratio is as natural as for the octave to be consonant in the 2:1 ratio."[45] In short, Zarlino was mistaken in imputing a universal harmony to nature.

It is obvious that Galilei was not inclined either toward the idols of the tribe or the theatre; but neither would he fall before those of the market place. He was critical of contemporary theorists who manipulated concepts to construct rigid rules, when the objects of their legislation had no precise definition or any real existence apart from sensation. They pretended to speak about the things themselves, he complained, when in truth they were talking about mere words. Such was their categorical prohibition of parallel fifths. Some parallel fifths sound well, Galilei objected; only the musical ear can be the judge. The musician, Galilei insisted, deals in a subjective realm in which the sense has sufficient powers unaided by the reason. "For the senses apprehend precisely differences in forms, colors, flavors, odors, and sounds. They know moreover the heavy from the light, the harsh and hard from the soft and tender, and other superficial accidents. But the

[44] *Discorso intorno all'opere di messer Gioseffo Zarlino da Chioggia* (Florence: G. Marescotti, 1589), pp. 116-117.
[45] *Ibid.*, pp. 92-93.

qualities and intrinsic virtues of things, with respect to whether they are hot or cold, humid or dry, only the intellect has the faculty of judging, through becoming convinced by experiment and not simply by the sense through the medium of the diversity of forms and colors or other circumstances. . . ."[46] This statement, written in 1589, while it seems to adumbrate the theory of primary and secondary qualities of Francis Bacon, Galileo, and Thomas Hobbes, only expressed what was already in the air. Ludovico Vives and Bernardino Telesio, among the philosophers Galilei may have known, had both revived this distinction of the ancient sceptics. For Telesio, however, the primary active qualities or forces were simply hot and cold, while Galilei went back to the four primary qualities of Aristotle: hot, cold, dry, and moist.[47] To isolate more specifically the source of Galilei's scientific orientation is difficult. The ancient atomists and sceptics were being widely read and commented on. As the musical preceptor of Giovanni Bardi's academy, the "Camerata," Galilei was in close contact with the prevailing intellectual currents. According to Pietro Bardi, the academy heard "discourses and instructions in poetry, astrology, and other sciences," as well as being entertained with music.[48]

[46] "Discorso intorno all'uso delle dissonanze" (1589-1591), Florence, Biblioteca Nazionale Centrale, Mss. Galileiani, Anteriori a Galileo, Vol. I, fol. 120v.

[47] *De generatione et corruptione*, ii. 2. 329b. Aristotle, however, does not speak of colors, flavors, odors, and sounds, except to say that whiteness, blackness, sweetness, bitterness, and similar perceptible contrarieties do not constitute basic elements.

[48] Pietro de' Bardi Conte di Vernio, "Lettera a G. B. Doni sull'origine del melodramma" (1634), in Angelo Solerti, *Le origini del melodramma* (Torino: Bocca, 1903), pp. 143-144.

Claude V. Palisca

Two important influences on Galilei may be indicated, however. The first was the Greek philosopher of the Peripatetic School, Aristoxenus of Tarentum.[49] Neglected by medieval and early Renaissance musical theorists because he was the *bête noire* of Boethius, he became known to musicians through Antonio Gogava's (however inadequate) Latin translation of his *Harmonics*, published in 1562. Ironically, the translation had been for Zarlino, who evidently received it too late to put it to use in his *Harmonic Institutions*. Unlike Plato, Aristotle, and Ptolemy, Aristoxenus was not concerned with fitting musical facts into a rational system; he aimed only to set down musical and acoustical observations and laws as they were gathered from sense experience. He recommended an empirical tuning approximating equal temperament. Serious consideration of equal temperament in theoretical writings begins characteristically with the discovery of this Greek authority who could be cited in its behalf. The Aristoxenian tuning was considered by Galilei the most practicable of the Greek systems for modern instruments.

Another important influence on Galilei's thought was Girolamo Mei, a Florentine humanist who resided in Rome. By the time Galilei first consulted him, in 1572, Mei had read every available ancient Greek and Latin source on Greek music. He communicated much of his data and conclusions to Galilei during the next nine years.[50] Mei's reve-

[49] Galilei left among his papers a translation of Aristoxenus into Italian, in Florence, Bibl. Naz. Cent., Mss. Galileiani, Ant. a Galileo, Vol. VIII.

[50] The extant letters from Mei to Galilei are printed in C. Palisca, *Girolamo Mei; Letters on Ancient and Modern Music* (American Institute of Musicology, 1960).

lations persuaded Galilei that his former teacher Zarlino and other contemporary theorists had misinterpreted Greek music. It was for a clarification of some points concerning this music that Galilei had first approached Mei. But in the course of their exchanges Mei succeeded in changing Galilei's entire philosophy, as the latter shows in his *Dialogo*.

Mei emphasized in his letters the necessity for distinguishing artistic from scientific facts: "The science of music goes about diligently investigating and considering all the qualities and properties of the constitutions, systems, and orders of musical tones, whether these are simple qualities or comparative, like the consonances, and this for no other purpose than to come to know the truth itself, the perfect goal of all speculation, and as a by-product the false. It then lets art exploit as it sees fit without any limitation those tones about which science has learned the truth."[51] The tendency in the Renaissance had been to base artistic rules on presumed scientific or metaphysical facts. Mei understood that this was a violation of the independent subjective nature of artistic procedures.

On one occasion, seeing that his correspondent clung to Zarlino's *senario* theory and to just-intonation, Mei suggested to Galilei that he try a simple experiment to prove whether voices sang the supposedly natural intervals. Mei wrote: "Stretch out over a lute (the larger it is, the more obvious will be what we wish to prove to the ear) two . . . strings of equal length and width, and measure out the frets under them accurately according to the distri-

[51] Letter of May 8, 1572, *ibid.*, pp. 65, 103.

bution of the intervals in each of the two species of tuning—the syntonic [just intonation] and ditonic [Pythagorean]—and then, taking the notes of the tetrachord one by one by means of the frets of each string, observe which of the two strings gives the notes that correspond to what is sung today. Thus without any further doubt the answer will result clear to anyone, even if what I have often fancied on my own more as a matter of opinion than judgment is not proved true."[52]

It is likely that Galilei went ahead to make this simple experiment, because he was soon convinced that the syntonic was not the tuning in use, but that neither was it what Mei had "fancied." That year, 1578, Galilei sent his first discourse to Zarlino under a pseudonym, to begin the polemic that was to last more than eleven years.[53] The climax of the controversy was the publication in 1581 of the *Dialogo* already mentioned, one of the most influential treatises of the late sixteenth century and probably the one that gave the greatest impetus to progressive musical techniques.

Once the seed of scepticism had been planted in Galilei's mind, its roots spread to every region of his thought. He worked out a new empirical theory of counterpoint that was based entirely on facts gathered from the practice of his contemporaries and predecessors. Before the Baroque as we know it really began, he had proclaimed many

[52] Letter of January 17, 1578, *ibid.*, pp. 67, 140.

[53] This "Discorso," sent to Zarlino on June 7, 1578, is mentioned in Zarlino's *Sopplimenti musicali*, in *Opere* (Venice: F. de Franceschi Senese, 1588-1589), Vol. III, pp. 5-6, and in Galilei's *Discorso* of 1589, pp. 14-17, but it has not itself survived.

of its ideals in his treatise on counterpoint—which remained, however, in manuscript.[54]

Toward the end of his life Galilei applied the experimental method to a problem that had come up in the polemic with Zarlino: to what degree were the numerical relationships usually associated with intervals on the basis of string-division truly bound up with the physical cause of these intervals? The tradition for the numbers assigned to the consonances was, as we have seen, a very old one, but Galilei had resolved to question even such venerable concepts. That the ratios of 2:1 produced the octave, 3:2 the fifth, and so on, was supposed to have been observed by Pythagoras in the weights of hammers at a blacksmith shop (see Plate II). In Galilei's last published work, a discourse refuting certain points made in Zarlino's *Supplements* of 1588, Vincenzo shows (as his son Galileo and Mersenne were later to do again) that these ratios produce the consonances usually associated with them only when their terms represent pipe or string lengths, and other factors are equal. It was generally believed at this time that the same ratios would also produce these consonances when they expressed relative weights of hammers, weights attached to strings, or the volume enclosed in bells or glasses. In the woodcut published in Franchino Gaffurio's *Theorica musice* (1492), the same numbers, 4, 6, 8, 9, 12, 16, appear in each picture, implying that they would always produce the same intervals, for example, A E a b e a' (see Plate II). Galilei seems to have been

[54] See C. Palisca, "Vincenzo Galilei's Counterpoint Treatise: a Code for the *Seconda Pratica*," *Journal of the American Musicological Society*, IX (1956), 81-96.

the first to upset this doctrine, which was so plainly false that in 1627 Mersenne was to exclaim: "I am certainly astonished that Macrobius, Boethius and other ancients, and after them Zarlino and Cerone, were so negligent that they did not make a single experiment to discover the truth and disabuse the world."[55]

About thirty years earlier in his *Discorso* of 1589 Galilei had declared: "In connection with [the theories of Pythagoras] I wish to point out two false opinions of which men have been persuaded by various writings and which I myself shared until I ascertained the truth by means of experiment, the teacher of all things."[56] Contrary to common belief, he explained, two weights in the ratio of 2:1 attached to two strings in the manner shown in Gaffurio's woodcut (Plate II) will not give the octave. The two weights must be in the ratio of 4:1 to produce the octave, 9:4 for the fifth and 16:9 for the fourth. Pythagoras plucking the strings marked 12 and 8 in the woodcut (lower left) would get the irrational interval equivalent to string lengths in the ratio $\sqrt{3} : \sqrt{2}$!

The second false opinion Galilei wished to correct was a consequence of the first. Since the pure octaves, fifths, fourths, and thirds were produced by string lengths in superparticular ratios (of the class $\dfrac{n+1}{n}$), and the compounds of these intervals (double octave, twelfth, etc.) by multiple ratios within the *senario*—3:1, 4:1, 5:1, 6:1— the Pythagoreans and Boethians recognized only these two classes of ratios as productive of consonance. But now Gal-

[55] *Traité de l'harmonie universelle* (Paris: Guillaume Baudry, 1627), p. 447, quoted in Hellmut Ludwig, *op.cit.*, p. 54.
[56] *Discorso*, 1589, pp. 103-104.

ilei could show that ratios outside these two classes could also produce consonances, as 9:4 and 16:9, when they represent string tension.

Galilei did not pursue this line of reasoning further in the printed discourse. However, he developed his theory more fully in two manuscript essays whose contents are unknown to historians of both science and music.

In an essay entitled "A Particular Discourse Concerning the Diversity of the Ratios of the Octave," probably of 1589-1590, Galilei reported on some experiments he made with strings of different materials, with weights, coins, and pipes.[57] The octave, Galilei demonstrated, may be obtained through three different ratios, 2:1 in terms of string lengths, which corresponds, he said, to linear measurement, 4:1 in terms of weights attached to strings, which is analogous to area or surface measurements, and 8:1 in terms of volumes of concave bodies like organ pipes, which corresponds to cubic measurements. In a second essay, "A Particular Discourse Concerning the Unison," of about the same date, Galilei noted the results of testing strings of various materials.[58] He found that to produce a true unison two strings had to be made of the same material, of the same thickness, length, and quality, and stretched to the same tension. If any of these factors was absent, the unison would be only approximate. Moreover, he discovered that

[57] "Discorso particolare intorno alla diversità delle forme del Diapason," Florence, Bibl. Naz. Cent., Mss. Galileiani, Ant. a Galileo, Vol. III, fols. 44r-54v. The essay may be dated through a mention of the printed *Discorso* of 1589 on fol. 45r and a parallel statement in the "Discorso intorno all'uso delle dissonanze," *loc.cit.*, Vol. I, fol. 60v, citing the present discourse.

[58] "Discorso particolare intorno all'Unisono," same collection, Vol. III, fols. 55r-61v.

if a lute were strung with two strings, one of steel and one of gut, and these were stretched to the best possible unison, the tones produced by stopping the strings at the various frets would no longer be in unison.[59]

What was the significance of these discoveries for the musician? First, he had to revise his fundamental concepts about musical sounds. The legendary sonorous or harmonic numbers had no real existence, Galilei showed. The sonorous number, which is referred to everywhere in the preceding literature as the material cause of sound, was a myth. It confused the corporeal—the vibrating body —with the incorporeal, the abstract numbers measuring the divisions of the body. Numbers, properly used, he emphasized, must refer to a particular dimension, of line, surface, or volume. And if numbers are properly applied, the octave or fifth cannot be said to have only one ratio, but a certain ratio according to stated conditions. It was therefore not true, as Zarlino had stated,[60] that the natural form of the octave is the duple ratio and can be none other, for the duple ratio can be found in dissonant intervals, as between two coins, when it will produce a tritone, or between the volumes of two pipes, when a major third approximately in the "intense" tuning of Aristoxenus will result.[61] All of his observations proved that numbers were significant only when applied to certain material relationships in sounding bodies, but meaningless as abstractions invoked to support this or that theory.

Moreover it is futile, Galilei showed, to try to prove

[59] *Ibid.*, fols. 59r-59v. [60] *Istitutioni harmoniche*, I, *xiii.*
[61] "Discorso . . . intorno all'Unisono," *loc.cit.*, fols. 49r-53v.

the superiority of one or another tuning system on mathematical grounds. The ear has no regard for systems; it operates on a purely subjective level that eludes quantitative measurement. The large major thirds used in the lute tuning do not seem objectionable because of the mellow quality of the gut strings, but those same thirds in the harpsichord's steel strings are less tolerable because of the sharper sound of such strings.[62] The only interval whose tuning is really critical is the octave, which the ear cannot stand imperfectly tuned. The other intervals are usually found in some deviation from the true ratios. The ear tolerates these small deviations because it cannot detect smaller differences than one ninth of a tone. Numbers, Galilei emphasized, are discrete quantities, while the intervals found by a viola player as he moves his finger down the fingerboard are points in a continuum that contains many "minimal particles, almost like Atoms," as he put it.[63] This infinity of points could yield an infinity of consonances and an even greater infinity of dissonances.

One may well ask at this point what effect Galilei's experiments, made in isolation and recorded in inaccessible manuscripts, could have had either on the course of music or of science. First, Galilei is only one of several whose thoughts were running in this direction at this time, though he was probably the most influential. Second, the essays were probably communicated to a group of musicians and humanists, since both discourses were written in reply to objections of certain "Aristoxenian friends" mentioned in them. The objections had probably arisen from the *Di-*

[62] Galilei already made this observation in *Dialogo*, pp. 47-48.
[63] "Discorso . . . delle forme del Diapason," *loc.cit.*, III, fol. 54v.

Claude V. Palisca

alogo of 1581 and the *Discorso* of 1589.[64] Moreover, the published writings of Galilei were known to succeeding scientists. Mersenne in his *Verité des sciences* (1625) recognized Vincenzo Galilei's priority in the discovery of the laws governing strings, pipes, and bells.[65] Mersenne clarified some aspects of these, such as the role of specific gravity and weight in determining the pitch of a string, but the essential concepts in what are known in acoustics as Mersenne's Laws he owed to Galilei.

There is a further link between Vincenzo Galilei and later scientific studies of sound. This link is Vincenzo's son, Galileo. Obvious though it seems, it has been consistently overlooked by biographers and historians of science and music. Vincenzo's books and manuscripts passed to Galileo in 1591 on the father's death. Moreover, during the period the experiments described above were being carried out, Galileo lived mainly at his father's home in Florence. In 1585 Galileo had abandoned his medical studies at Pisa and returned to Florence, there to remain until he took the post of lecturer in mathematics at Pisa in 1589.[66] While at home Galileo must have become aware of and perhaps even involved in his father's experiments, for the very problems his father treated appeared prom-

[64] Among the musicians who frequented Bardi's house were Giulio Caccini, Jacopo Peri, and Alessandro Striggio. The unnamed Aristoxenians are referred to also in "Discorso . . . intorno all'Unisono," *loc.cit.* III, 58v; *Discorso*, 1589, pp. 104, 116; and "Discorso . . . delle forme del Diapason," *loc.cit.*, III, 45r.

[65] Mersenne, *La vérité des sciences* (Paris: T. Du Bray, 1625), p. 616. Cf. Mersenne, *Correspondance*, I, 203.

[66] The appointment was conferred in July, and Galileo gave his inaugural lecture on November 12. Cf. Antonio Favaro, "Serie settima di scampoli Galileiani," in *Atti e memorie della Reale Accademia di scienze lettere ed arti in Padova*, nuova serie, VIII (1892), 55.

132

inently in the *Dialogues Concerning Two New Sciences*.[67]

Someone might suggest, though, that the influence proceeded in the opposite direction: from son to father. But this seems unlikely for a number of reasons. Galileo while in Florence was preoccupied with mathematics, an interest which had prompted his leaving medicine. There is no trace of experiments in the area of acoustics by Galileo at this time. In fact, the earliest study showing any trace of experimental method is the *De motu*, a manuscript prepared between 1589 and 1592 in Pisa. In this essay Galileo challenged a number of Aristotelian solutions to classic problems of motion.[68] On the other hand, the possibility that the father may have encouraged an empirical direction in the young mathematician is not to be excluded.

While the possibility of such an influence is only conjectural, it is a striking fact that Galileo in the section on the consonances in the *Dialogues Concerning Two New Sciences* repeats in the conversation between the two interlocutors, Sagredo and Salviati, the thought process that is documented in the discourses of Vincenzo Galilei. In the following passage Sagredo sums up the doubts Vincenzo had expressed upon the definitiveness of the ratios assigned to the consonances:

"For a long time I was perplexed about the ratios of the consonances, since the explanations commonly adduced from the writings of authors learned in music did not

[67] *Discorsi e dimostrazioni matematiche intorno à due nuove scienze* (1st ed.; Leyden: Elseverius, 1638), in *Opere*, Edizione Nazionale (Florence: G. Barbèra), VIII (1898), 139ff.

[68] Raffaele Giacomelli, *Galileo Galilei Giovane e il suo "De motu"* (Pisa: Domus Galileana, 1949), pp. 19ff.

strike me as sufficiently conclusive. They tell us that the diapason, i.e. the octave, is contained in the duple ratio, the diapente, which we call the fifth in the sesquialtera [3/2] etc.; because if a string is stretched on the monochord and sounded, and afterwards a bridge is placed in the middle and the half-string is sounded, an octave will be heard between the two. If the bridge is placed at one-third the length of the string, then, plucking first the open string and afterwards two-thirds of its length, the fifth is sounded. For this reason they say that the octave is contained in the ratio of two to one and the fifth in the ratio of three to two. This explanation, I repeat, did not impress me as sufficient to justify the determination of the duple and sesquialteral ratios as the natural ratios of the octave and fifth; and my reason for thinking so is as follows. There are three ways to raise the pitch of a string: first, by shortening it; second, by tightening or stretching it; third, by making it thinner. If we maintain the tension and thickness of the string constant, we obtain the octave by shortening it to one half, i.e. by sounding first the open string and then one-half of it. But if we keep the length and thickness constant and we wish to produce the octave by stretching, it will not suffice to double the weight attached to the string; it must be quadrupled. If the string was first stretched by a weight of one pound, four will be required to raise it to the octave. . . .

"Granted these very true observations, I could see no reason why those wise philosophers should have established the duple ratio rather than the quadruple as that of the octave, or why for a fifth they should have chosen the

sesquialtera [3:2] rather than the dupla sesquiquarta [9:4]."[69]

Up to this point Galileo has reproduced the arguments found in his father's discourses. But now Galileo departs from this line of reasoning to announce that he has discovered real grounds for a constant numerical relationship between the tones of a consonance or of any other interval. This constant relationship is the ratio between the two frequencies of vibration. Such a ratio, he shows, is the inverse of that given by the string lengths. This, as we have seen, was already suggested by Benedetti, who gave no proof for it. Then Beeckman in 1614-1615 demonstrated the rule geometrically, and finally Niccolo Aggiunti, a pupil of Galileo, recorded a proof for the fact in 1634, four years before the publication of Galileo's *Dialogues*.[70] With the Pythagorean ratios reinstated, a new cycle of number theories could begin and did in fact.

Meanwhile, the empirical trends had transformed the face of seventeenth century music. Some composers still wrote in a labored polyphonic style, but the dominant fashion now was the accompanied monody and the few-voiced concertato. Seconds and sevenths, dissonances previously used with great restraint, were now introduced freely for expressive reasons, while the augmented fourths and diminished fifths were treated almost like consonances both melodically and harmonically. Few composers any longer respected the diatonic modes, which Zarlino had sought to keep pure of foreign tones. Chromaticism had become rampant in the last decades of the sixteenth cen-

[69] *Opere*, VIII, pp. 143-144 (my translation).
[70] Cf. Mersenne, *Correspondance*, II, 234-235.

tury and was now the backbone of almost every piece that sought to express the more intense passions.

It would be wrong to conclude from this exposition that the sensualism and freedom of early Baroque music can be ascribed mainly to the liberalizing force of scientific investigation. The empirical attitude operated on two levels. On the objective level of the observation of nature, with which I have been primarily concerned, the studies of the nature of consonance and of sound engendered an enlightened approach to some ancient problems of musical composition, performance, and instrumental tuning. But empiricism was also at work on the practical level of artistic effort. Whether influenced by scientists or not, musicians have always experimented with new resources. Such experimentation was particularly intense from around 1550 to 1650. The urge to abandon the rigorous methods of old and try the new probably had its origin in the same humanistic ferment that produced the scientific revolution. Science cannot therefore be held responsible for the empirical tendencies of musical practice, because both depended on a common cause.

Scientific thought did reveal, however, the falseness of some of the premises on which existing rationalizations of artistic procedures had rested. Musicians exposed and inclined to this new thought were liberated by it from some of the superfluous strictures of the older practice. In an age that admired reason and suspected the senses, it was not enough to find a new path through artistic experimentation; it was important to prove the fallacy of the old and to justify the new by adequate theoretical concepts. To cite one example: in 1533, about fifty years before Gal-

ilei upset Zarlino's system, Giovanni Maria Lanfranco recommended a keyboard tuning that approximated equal temperament.[71] But not until the seventeenth century did written music really exploit the possibilities of such a keyboard. The new solutions had to be openly debated and endorsed by common consent before composers generally had courage to imitate the isolated experimenters. In a society in which the composer depended directly upon the consumer, many forces tended to preserve and canonize established practice and to discourage change—fear of open criticism, respect for the traditions and authorities of the church, the layman's eternal resistance to the unfamiliar. By creating a favorable climate for experiment and for the acceptance of new ideas, the scientific revolution greatly encouraged and accelerated a direction that musical art had already taken.

Finally, the new acoustics replaced the elaborate conglomeration of myth, scholastic dogma, mysticism, and numerology, which was the foundation of the older musical theory, with a far less monumental but more permanent and resistant base. Unlike the old metaphysics, this new science recognized the musician's prerogative. While it taught him to understand the raw material he received from nature, it left him free to employ it according to his needs and to frame his operating rules according to purely esthetic motives.

[71] *Scintille di musica* (Brescia: Lodovico Britannico, 1533).